Renaissance Ornament Prints and Drawings

Renaissance Ornament Prints and Drawings

JANET S. BYRNE

Curator, Department of Prints and Photographs

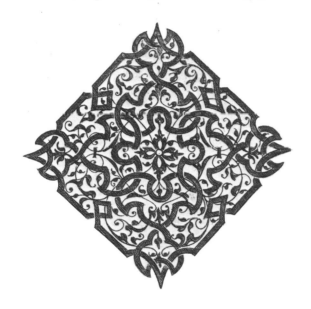

The Metropolitan Museum of Art

NEW YORK

THIS BOOK was published in connection with an exhibition at The Metropolitan Museum of Art, New York, from December 11, 1981, to February 14, 1982. The exhibition was made possible by a grant from Reliance Group, Incorporated.

PUBLISHED BY

The Metropolitan Museum of Art, New York

Bradford D. Kelleher, Publisher

John P. O'Neill, Editor in Chief

Amy Horbar, Editor

Peter Oldenburg, Designer

ON THE JACKET
Detail of number 49, Daniel Hopfer, acanthus ornament, etching

LIBRARY OF CONGRESS CATALOGING IN PUBLICATION DATA

Byrne, Janet S.
 Renaissance ornament prints and drawings.

 "Published in connection with an exhibition at the Metropolitan Museum of Art, New York, from December 11, 1981 to February 14, 1982."
 Includes index.
 1. Prints, Renaissance—Exhibitions. 2. Drawing, Renaissance—Exhibitions. 3. Decoration and ornament, Renaissance—Exhibitions. I. Metropolitan Museum of Art (New York, N.Y.) II. Title.

NE441. B97 760'. 094'07401471 81-18806
ISBN 0-87099-288-0 AACR2

Contents

Foreword
 Philippe de Montebello 7

Acknowledgments 9

Introduction 11

Text 23

Credits 140

Index of Artists Illustrated 143

Foreword

SINCE ITS FOUNDING in 1916, the Department of Prints and Photographs at The Metropolitan Museum of Art has actively collected prints depicting ornamental patterns and designs. The Museum's holdings in the area of Renaissance prints are particularly strong, and the selection in this volume, published to accompany the exhibition *Renaissance Ornament Prints and Drawings*, amply displays the virtuosity and inexhaustible invention of Renaissance artists and craftsmen. Drawing upon the rich vocabularies of antique and other motifs, designers created fanciful and exquisitely intricate patterns filled with a variety of classical devices, hybrid creatures, and exotic plant formations to adorn buildings, fountains, furniture, arms, armor, books, jewelry, precious objects, and other fixtures of their world. These designs, modest works of art, provide abundant information not only about the substance and texture of Renaissance life, but also about the sources and stylistic impulses of the period that produced them.

I wish to thank Janet S. Byrne, Curator in the Department of Prints and Photographs, for the realization of this exhibition and for the creation of this splendid publication with its enlightening essay on the stylistic evolution and significance of ornament drawings and prints during the Renaissance. Both exhibition and publication admirably acquaint the viewer and reader with the refined and multifarious pleasures offered by these works on paper.

PHILIPPE DE MONTEBELLO, *Director*
The Metropolitan Museum of Art

Acknowledgments

NO ONE who knows the ways in which early ornament prints appear—out of context, in unidentified and incomplete sets, or gathered in scrapbooks of designs by a variety of artists—can work with the Metropolitan Museum's extraordinary and extensive collection without becoming aware of the very large debt owed to the Print Room staff. Assiduously sought and purchased by William M. Ivins, Jr., and A. Hyatt Mayor, early ornament prints are more easily studied in this museum than anywhere else, except Berlin's Kunstbibliothek and London's Victoria and Albert Museum. The wide knowledge displayed by the Print Room staff, notably Margaret Daniels Abegg, Anne Waterson Gordon, and the late Olivia H. Paine, all of whom painstakingly identified and catalogued the collection, must be acknowledged.

To have been introduced to the world of ornament prints and then led through its tortuous paths by Miss Paine, and later to have experienced months of personal instruction about ornament drawings from the late Dr. Rudolf Berliner, makes me especially fortunate.

Colta F. Ives and the rest of my colleagues who sympathized with me while I struggled with the imponderables that the writing of this manuscript presented must be heartily thanked, as must my patient editor, Amy Horbar. Both Joan Holt and John P. O'Neill also helped immeasurably—and tactfully—with the preparation of the manuscript.

Renaissance Ornament Prints and Drawings, an exhibition on view in the Galleries for Drawings, Prints, and Photographs from December 11, 1981, to February 14, 1982, was funded by Reliance Group, Incorporated. Doris Halle, Olga Raggio, James David Draper, James Parker, and Clare Vincent gave generously of their time and effort in the planning and installation of the exhibition.

JANET S. BYRNE

NOTE: The first curator of prints at the Metropolitan Museum, William M. Ivins, Jr., started the Museum's collection of ornament prints and wrote several illuminating articles on them in *The Metropolitan Museum of Art Bulletin,* notably "'Ornament' and the Sources of Design in the Decorative Arts" 13 (1918): 35–41; "Notes on the Exhibition of Ornament" 14 (1919): 107–11; "The Philosophy of Ornament" 28 (1933): 93–97.

Introduction

LONG TIME AGO William M. Ivins, Jr., pointed out that probably no one ever invented a wholly new and original ornament design. Ornament styles develop gradually, like language, with one motif at a time added to the vocabulary. By the sixteenth century ornament designs were increasingly made on paper, drawn by designers or printed by engravers and woodcutters making patterns for mass distribution. There are a great many more Renaissance ornament prints and drawings than one expects, and trying to impose any kind of order serves only to demonstrate that it cannot be done definitively or to complete satisfaction. Entire categories escape through the holes in the fabric of any order, be it stylistic, chronological, or geographical.

The most immediate schematization is a sorting into two groups: motifs—for example, a strip of leaves and vines to be adapted for various objects, materials, and spaces—and designs for specific objects—for example, a jeweled pendant or a table. Designs for specific objects can be subsequently divided into copies of existing objects and projects as well as patterns for new objects.

These basic distinctions are as necessary a consideration in the understanding of Renaissance ornament prints and drawings as are measurements or descriptions of techniques and materials. Given a Renaissance drawing to assess—a cup, for example—one must try to determine whether it is an artist's design—a project drawing—for a goldsmith, an engraver's preparatory drawing copying an existing cup, or a drawn copy of a print after a designer's project.

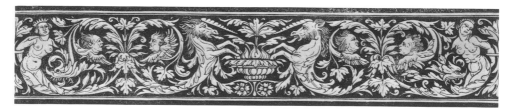

Peter Flötner. Strip of ornament. Woodcut. Harris Brisbane Dick Fund, 1927 (27.54.79)

AT ITS BEST, ornament design on paper is a fresh, inventive drawing solving old problems with style, and unfortunately there are fewer of such drawings than one would wish. In the early Renaissance an ornament drawing was usually made for a definite reason, not just as an idle sketch. It concerned only the artist, his client, and possibly his shop, but later, drawings were also made not for specific clients, but simply to be accumulated as a stock of samples.

Great drawings cannot be expected from artisans, whose skill at their craft often exceeds their ability to draw. Artisans do not usually design a motif without an object in mind, and they are apt to distort a drawn object so that its function and details can be understood and agreed to by the client. For example, a chair is often drawn by a craftsman at eye level, but with its seat seen from the top. Only an artisan would show a chair this way; an artist would show an idea of a chair, leaving the construction to the imagination and experience of the cabinetmaker.

There is a large body of ornament drawings—sketches and copies after existing objects—that has become extremely interesting with the passage of time even though the drawings are not especially beautiful. Often students' work, they not only represent buildings and monuments now lost, but they also record the sources of the Renaissance ornament vocabulary. By studying famous Renaissance sketchbooks — the *Codex Escurialensis,* the album of Pierre Jacques, the Ashby-Coner sketchbook, and that of Amico Aspertini—it is possible to see that many Renaissance motifs come straight from Roman painting, sculpture, and architecture. The Renaissance practice of lending sketchbooks

12

to friends and students instructed and inspired designers who had not been to Italy. When Philip II of Spain was building and decorating the Escorial, he gathered a library of ideas, both texts and pictures, purchasing for his designers some five thousand prints and drawings in addition to the *Codex Escurialensis*. Decorative ideas, especially those from classical antiquity, as well as the latest Italian Renaissance fashions were therefore known in sixteenth-century Spain.

An example of designs that started out as sketchbook records of someone else's interesting ideas to be later incorporated as needed into an artist's vocabulary is the Museum's so-called *Spanish Grotesques* (65–67). An incomplete group of twenty-two sheets and fragments from the sketchbook of an unidentified sixteenth-century Spaniard, the grotesques are copies of fresco paintings or painted stuccos in the style of the classical grotesque ornament designed by Raphael and his school to decorate Roman palaces. What must have been blank pages and empty spaces were later filled with extravagant absurdities like those by Cornelis Floris of Antwerp (63).

Another kind of sixteenth-century ornament drawing is the deluxe presentation made for patrons. Known in at least five or six examples by Jacques Androuet Du Cerceau, highly finished drawings of tombs, fountains, trellises, buildings, or goldsmiths' work on sumptuously bound vellum leaves cannot be projects: there are too many kinds of objects and too many examples of each kind in a single volume. By definition a project is a preliminary study made to be executed; no one patron could use so many of any object shown, and if a design were to be used it would require study of the practical considerations involved before the object could be constructed. Although the exact purpose of volumes like this is unclear, it is thought that they were plans for pattern books presented to a patron with the hope that he would underwrite the cost of publication. The patron thereby received a unique and valuable gift along with the most current information about fashions, and at the same time he achieved a reputation as a generous donor.

There is at least one volume of sixteenth-century ornament drawings in existence clearly destined to be engraved and published as a book, although no such book of engravings is known. The volume is in the New York Public Library's Spencer Collection and was drawn by an unidentified designer called the Master of 1573 because he wrote 1573 on almost every drawing. Mainly occupied with designs for tombs and furniture, he provided his clients with choices by splitting his designs with a center line and on each side of the median changing details or rearranging their order. This is a designer's device found less often in the sixteenth century than in the eighteenth. Other volumes of pattern drawings to be engraved are probably hiding in inconspicuous bindings in private libraries.

An extremely specialized variant of sixteenth-century ornament drawings is the architectural drawing. There were relatively few finished drawings made for clients. For masons and builders there were plans and details, often with instructions in longhand. Faced with a sixteenth-century measured architectural elevation, one can usually conclude that it is a record of an existing building, not a design for a new one. Architectural drawings and prints are represented in this text only by ornamental details—doors, windows, chimneypieces—or by designs for tombs, fountains, and festivals.

Architectural author-designers—Sebastiano Serlio, Jean Bullant, and Philibert de l'Orme—made ornament drawings to illustrate their books, turning the finished drawings over to the woodcutter or engraver. As visual explanations of ideas, these drawings could not be used by builders without modifications and specifications. De l'Orme, incidentally, complained bitterly about the way the printmaker distorted his drawings.

Still another kind of ornament drawing is the inventory drawing. Early printed inventories of royal or religious treasuries had woodcut illustrations, just as even earlier manuscript inventories had painted or drawn illustrations. Inventory drawings appear in volumes or in

14

groups, not singly, and they are apt to have numbers, descriptions, names, dates, or some sort of identifying information, for example, "Gold and silver vessels in the oak cupboard in the north chamber, Castle Erewhon, October 15, 1575."

Although sixteenth-century ornament drawings are almost never signed, there are some especially rare, not necessarily beautiful ones that were made to serve as contracts, and they are dated and signed by both the artist and the client. In France in the past, this kind of contract

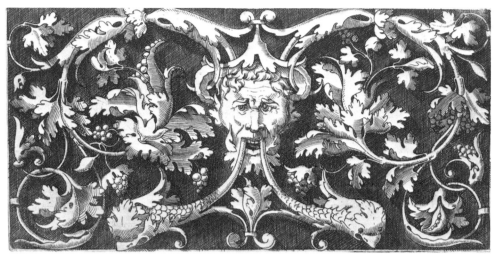

Enea Vico. Rinceau with mask and sea monsters. Engraving.
Harris Brisbane Dick Fund, 1953 (53.600.55)

found its way into the personal archives of notaries, not into any central legal depository; consequently a great many have perished.

Last among ornament drawings (leaving aside fakes and beginners' copies of prints or of their masters' designs) is the school exercise: for example, a student in the eighteenth century was given an assignment to design a sixteenth-century object. Not intended to fool anyone, but rather meant to display the student's knowledge of style and technique, school exercises, which may look genuinely old several hundred years

15

later, demonstrate why ornament drawings need to be carefully considered before identification and attributions can be made. Is the paper right? Is its date roughly the same as the date of the subject? Has the designer used the black chalk underdrawing of the sixteenth century or the lead pencil of centuries later? Has he made a working object or a meaningless accumulation of sixteenth-century motifs?

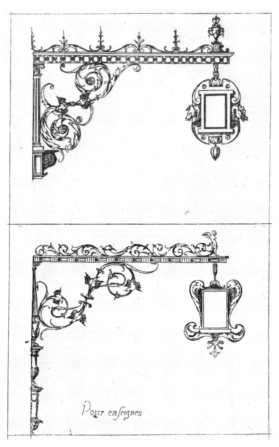

Jacques Androuet Du Cerceau.
Two designs for wrought iron signboards.
Etching. Harris Brisbane Dick Fund, 1932 (32.55.1(10))

16

ALTHOUGH they occasionally add something new, printed patterns are by definition a vulgarization and popularization. In the sixteenth century, if not today, no one bothered, except for experiment, to make a print unless he wished to duplicate an image. The spreading of wealth to the merchant class meant that the court and the church were no longer the only patrons of artists, and the increased demand for expensive decorative objects was met by local artisans who needed patterns to follow; therefore, duplicating an image became profitable. Ornament prints were always a commercial venture, and printmakers, trying to earn a living, reduced the inventions of painters like Raphael and Mantegna to formulas to be copied in embroidery or metalwork. The development of papermaking and printmaking techniques from the late fifteenth century on, together with the increased demand for patterns, resulted in a greater number of ornament prints than drawings.

By their very modest nature, ornament prints offer the designer an opportunity to express himself in ways he would never try if he were creating a major work of art. Just as medieval misericords and cloister capitals contained drolleries, ornament designs, especially those that predate the Council of Trent (1545–63) and its exclusion of pagan subjects from Christian church ornament, were allowed a good deal of freedom. Erotic images and emblems constantly occur in Renaissance ornament, sometimes explicitly but often hidden in otherwise unexciting decoration.

The rarest ornament prints are those that were intended to be decorations themselves. Because they were meant to be cut apart and pasted on walls and ceilings, on boxes, books, picture frames, musical instruments, and furniture, they have been destroyed. A few escaped cutting and pasting and are known in unique impressions, having survived because they were hidden in storerooms and closets like leftover rolls of wallpaper. The sixteenth century saw the production of giant woodcuts definitely intended for pasting on walls. Designs were sectioned, cut on more than one woodblock, printed on separate sheets of paper, and

pasted together to form a decoration. Finding a complete set of un-pasted sections today is a triumph for museums and collectors (1–4).

Engravings, too, were made to be pasted. Perhaps the earliest were decorations for box tops produced in Florence sometime between 1465 and 1480. Only twenty-four of these early engravings are recorded, and in only one or two impressions (none are recorded in American collections). With lovers, cupids, garlands, and wreaths, often hand colored, they were decorations to be pasted on the round or oval lids of ladies' work- and toilet-boxes.

Trying to extend the market for ornament prints, some early designers deliberately drew ambiguous and conservatively designed objects with datable details kept to a minimum. From a commercial point of view, it paid to design an object that could be a saltcellar, a font, the basin of a fountain, a sarcophagus, or a wooden chest (126). Long before the end of the century, however, the production of extraordinarily involved, wildly extreme mannerist designs suggested that the designers no longer cared about extending their market with time—only the latest fashion would do. The nouveaux riches must have been the desired market rather than the upper bourgeoisie, who usually want beautiful, simple, timeless designs for objects that can be easily resold.

After they have served their purpose as designs, ornament prints are often destroyed. When the vogue for a costume or a piece of furniture is over, the pattern is useless except as a record of the past. The ephemeral nature of patterns is demonstrated by the fate of designs for furniture and woodwork dating somewhere between 1540 and 1560. The furniture designed by an unknown German, Master HS (who signed his work with his initials and with crossed arrows and a carpenter's square), evidently went out of style, and when his prints no longer sold, the shop where they were remaindered ran them through the press again so that different blocks printed on the blank versos. The prints were then trimmed to suit the new pictures, and in the process, the edges of the original patterns were haphazardly cut.

18

Once printed ornament designs existed it took no time at all before someone thought of using them for whole books. A torrent of little books of patterns began to be published, starting in the 1520s. There were books for lettering and writing, for lace, embroidery, weaving, bookbinding, tailoring, ironwork, and furniture, as well as books for armorers, potters, painter-decorators, woodcarvers, goldsmiths, and jewelers. Successful artisans—goldsmiths, for example—who were competent smiths but were unable to design could buy pattern books by Hans Brosamer, Jacques Androuet Du Cerceau, Paul Flindt, Georg Wechter, Jonas Silber, and Mathias Zündt.

The very nature of pattern books led to their ultimate destruction. Individual patterns were often torn out for use, sometimes tacked on the wall, traced, pricked, chalked, oiled, or perhaps just fingered to death in the transfer process. To find a complete early embroidery book in good condition is virtually impossible. Lace and embroidery books were often used by nonprofessionals. Ladies were expected to do needlework but not necessarily to make their own designs. Therefore the ladies increased the demand for, and consequently the supply of, embroidery books.

For the most part, however, early pattern books were intended for professionals; they very often say so in the title, and most of them offer

Balthazar Sylvius. Three moresque designs. 1554. Engraving.
Harris Brisbane Dick Fund, 1937 (37.13.6(28))

little or nothing by way of instructions for use, assuming that the user would know what to do with the patterns. For instance, Heinrich Vogtherr's *Ein frembds vnd wunderbars Kunstbuechlin allen Molern Bildschnitzern Goldschmiden Steinmetzen Schreinern Platnern Waffen vñ Messerschmiden hochnutzlich zu gebrauchen der gleich vor nie keins gesehen oder inn den Truck kommen ist* ("A new and wonderful little art book such as has never been seen by anyone or published; very useful for painters, woodcarvers, goldsmiths, stonecutters, carpenters, armorers, and cutlers"), published in Strassburg in 1538, tells in the short introduction nothing about what to do with the pages of men's and women's headdresses, styles of parade armor, feet (bare or in Roman sandals), hands in every conceivable position, and a variety of architectural capitals and pedestals. Instead, Vogtherr tells why he made his book, aimed at third-rate artists and artisans:

> Because the Good Lord, through Divine Ordinance, has brought about a marked reduction of all ingenious and liberal arts here in Germany, causing so many to turn away from art and try other trades, that in a few years painters and woodcarvers would seem to have all but disappeared. To prevent painters, goldsmiths, silk embroiderers, stonecarvers, cabinetmakers, and so on from giving up and tiring, I, Heinrich Vogtherr, painter and citizen of Strassburg, have assembled an anthology of exotic and difficult details that should guide the artists who are burdened with wife and children and those who have not traveled. It should store stupid heads and inspire understanding artists to higher and more ingenious arts until art comes back to its rightful honor and we lead other nations.

A variant of pattern books, the emblem book, popular in the sixteenth century, remains an esoteric field of study in the twentieth century. Emblems were a gentleman's game, being partly derived from heraldry, in which animals and objects become devices or symbols. A lion, a leopard, a harp, a mailed fist all stood for qualities recognizable even today. Poets and artists seeking patronage also had to play the emblem game, and working together produced volumes of images so

elaborate that their meanings were understood by comparatively few in their own day, and today only by scholars.

To those of us who have less academic interest in the subject, the curious preoccupation of the emblem writers does not merit a great deal of consideration except in the case of Dürer's *Triumphal Arch,* which of course is not a book, but a wall decoration (26–29). Emperor

Heinrich Vogtherr. Two pages of patterns from *Ein frembds vnd wunderbars Kunstbuechlin.* Strassburg, 1538. Woodcuts. Rogers Fund, 1919 (19.62.2)

Maximilian commissioned the court poet Stabius to write an emblematic prospectus for the *Arch.* Whatever the program called for, it was Dürer who used the emblems in such a way that anyone not knowing the difference between two long-legged birds—a crane (symbol of pride and feminine beauty) and a stork (symbol of piety)—could nevertheless be pleased by their appearance on the *Arch* among the leaves, whether these leaves be emblems of victory (laurel), peace (olive), or

21

immortality (ivy). One of the entertaining things about emblem explainers is that in their eagerness to educate the uninitiated they have sometimes mistranslated the image. Since the meanings of emblems differ from place to place and century to century, reading emblems today is simply an exercise in virtuosity and may lead to utterly mistaken conclusions.

IVINS'S STATEMENT that probably no one ever invented a wholly new and original design makes sorting ornament prints and drawings into motifs seem fruitless. However, by using such an elementary approach and by subsequently tracing sources, one can begin to understand a given designer's success or failure with the existing ornament vocabulary. Finally, by considering various examples of a single motif—each documented as accurately as possible with designer's name, country, and date—one can learn more about style than can be learned any other way.

There is no possibility of exhibiting or discussing more than an arbitrary selection of motifs and subjects. Motifs are represented by masks, children, leaves, monsters, grotesques, caryatids, candelabra, cartouches and frames, trophies, and heads. Objects fall into the categories of arms and armor, jewelry and precious objects, cups and vases, furniture and church furniture. The final category is architecture, considered only as ornament.

Hans Sebald Beham. *The Little Jester.* 1542. Engraving.
Harris Brisbane Dick Fund, 1917 (17.3.467)

Text

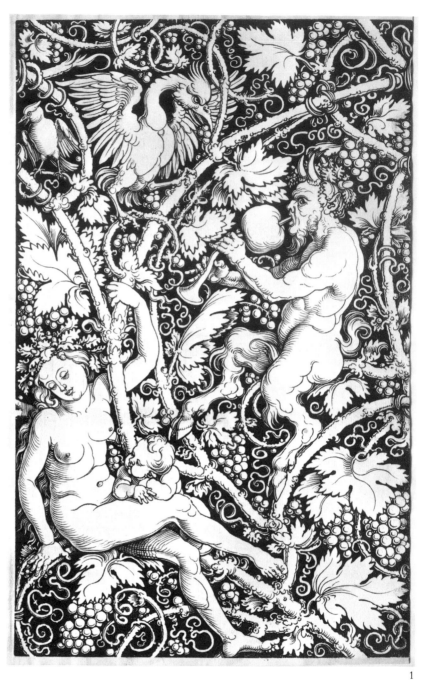

1, 2. A pair of woodcuts (about 1515) usually ascribed to Dürer's workshop was intended to be pasted on a wall like wallpaper. The design is derived from Dürer's engraving, made in 1505, of a satyr family, an antique theme probably introduced to Dürer by the Italian engraver Jacopo de' Barbari, whom he had met in Venice and again when Barbari lived in Nürnberg. The two woodcuts were meant to be used in multiple impressions, with the satyrs back to back. The grapevine travels sideways from one woodcut to the other but will only mesh at the top and bottom with another impression of the same block. The

24

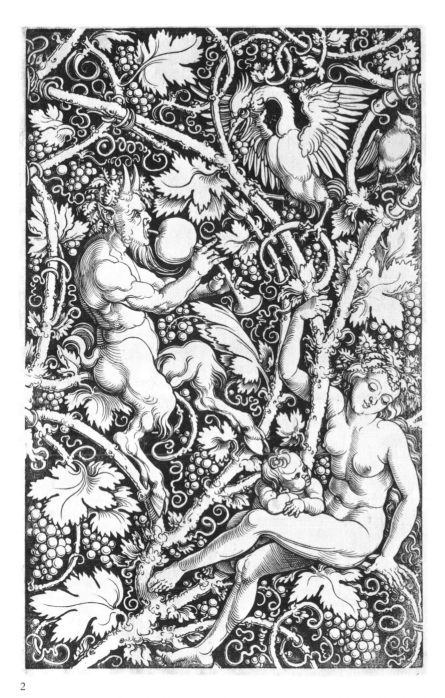

2

bare branches make a bold geometric pattern akin to those found in textiles, especially Venetian ones. Dr. Christian von Heusinger of the Herzog Anton Ulrich-Museum in Braunschweig has observed that the Metropolitan Museum's two woodcuts, the first he has seen with a black background, are printed from blocks that must be earlier and closer to Dürer than those known in other collections. The later, more carelessly cut blocks have a black design on a white background, which could be variously colored by hand.

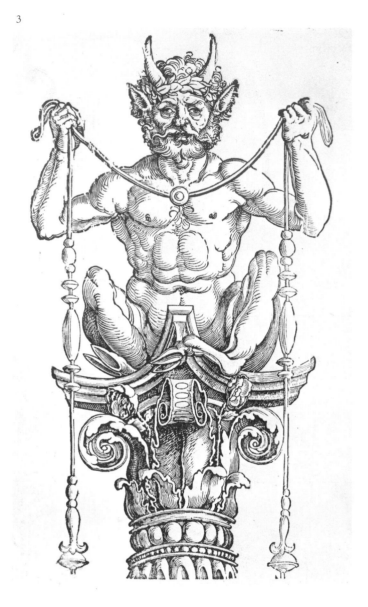

3

3. A vertical decoration meant to be pasted on a wall was produced about 1515 by Dürer's shop. On a Composite capital at the top of a column sits a satyr, symbol of the sexuality of man, holding up an elaborately knotted, beaded, and tasseled rope. Beneath the satyr the shaft of the column extends through two additional woodblocks to the base; the four pieces form a column altogether six feet high by three feet wide. Complete sets of four sheets are seldom found, and the Museum's collection includes only the top and the bottom.

4. Hans Sebald Beham's motif of sea monsters fighting with weapons composed of dead fish (weapons reminiscent of the medieval fool's stick) comes straight from Andrea Mantegna's *The Battle of the Sea Gods* of 1485–88 (54ab). Beham's woodcut, made about 1520–25, was intended to be multiplied sideways and used as a wallpaper frieze. It is only one example of the many ways in which *The Battle of the Sea Gods* was used by ornament printmakers. Beham's tritons are bound together, and although each has a firm grip on the cords from a pendant jewel, the cause of their argument, they do not look as angry as the Mantegna tritons. Instead, they are merely contestants, ready to score without doing damage.

5. Possibly engraved by Francesco Rosselli in Florence sometime between 1470 and 1480, a plate of strips and squares was meant to be cut apart and pasted on wood or cardboard to make a picture frame. With one upright and one horizontal strip, the framemaker needed two impressions of this engraving but would have an extra set of four square corners when he was finished. Such frames were assembled in shops, not homes, and were usually hand colored.

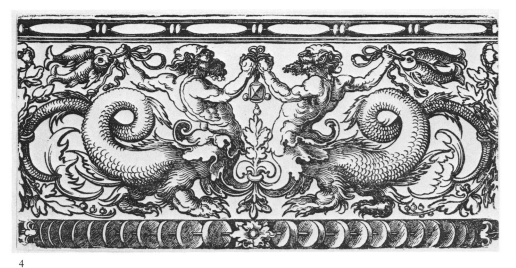

4

5

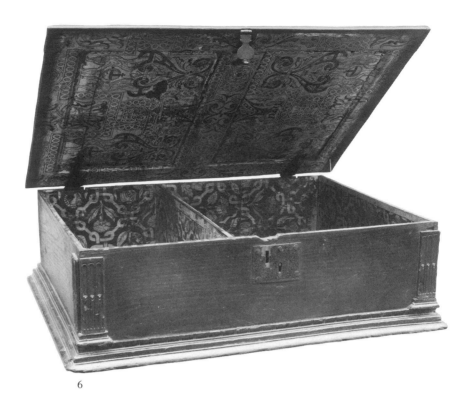

6

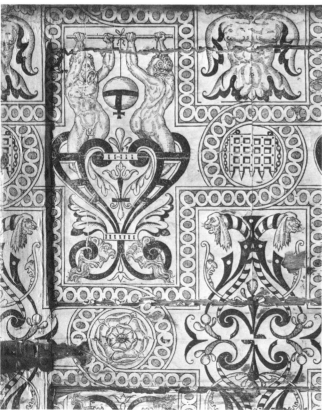

7

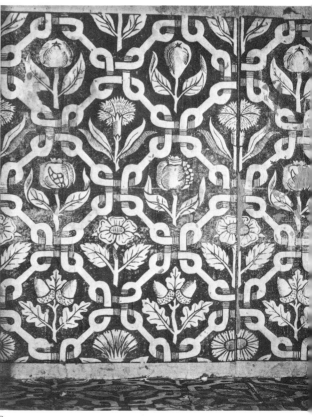

8

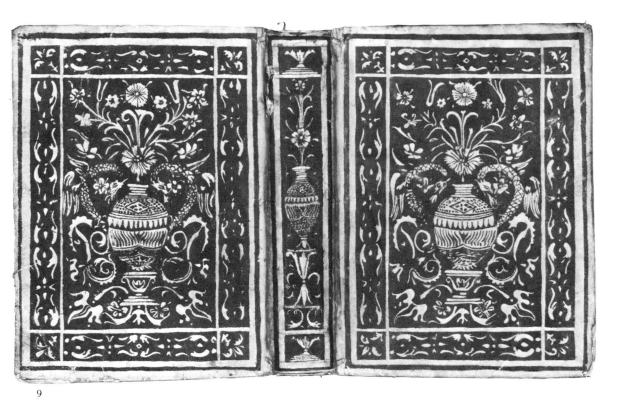

9

6–8. Scraps of sixteenth-century English wallpaper were used to line an early-seventeenth-century oak box. Printed in black, the woodcut pattern of the paper in the lid is composed of heraldic elements including the Tudor rose and the Beaufort portcullis, a badge inherited by the Tudors from Margaret Beaufort, mother of Henry VII. Although often referred to as a Bible box, there is nothing religious about the decoration of the box (twenty-seven by twenty-one by nine inches, with a partition unequally dividing the interior). The paper in the bottom has a pattern of emblematic fruit and flowers—apples, pears, quinces, pomegranates, carnations, roses, acorns—isolated by an interlocking, framing chain. This paper suggests that the box was meant for documents, writing materials (there are no ink stains), or small love tokens—for example, embroidered gloves or purses.

9. Two unillustrated religious tracts published in Basel in 1521 were soon thereafter bound together in Venice. The vellum binding was printed in black ink with a woodcut design of vases, flowers, and leaves. If paper had been used instead of vellum, the handsome patterns, quite typical of book ornament of the time, would have printed more distinctly.

10. An extremely rare moresque pattern dating between 1520 and 1530 is attributed to a north Italian designer known as Master f (he signed his work with only the letter *f*). Of little value to the unidentified person who attempted to protect a print by Daniel Hopfer (49), the moresque was pasted as a lining on the back of the Hopfer. To make matters worse, someone later unsuccessfully tried to peel off the Master f. A Gdańsk collector who died in 1842 and is listed only as Würtemberg (Frits Lugt, *Les Marques de collections de dessins et d'estampes,* Amsterdam, 1921, no. 2606) wrote his mark at the bottom left, partly on the back of the Hopfer and partly on the front of the Master f; the damage to the moresque must have occurred before 1842.

10

11. Possibly while he was on his second trip to Venice, in 1505–7, Dürer copied six interlace designs from engravings after drawings by Leonardo. Leonardo himself was not a printmaker, and scholars are still undecided about who made the engravings, each of which was inscribed *Academia Leonardi Vinci,* with slight variations. When Dürer made his woodcut copies he omitted the inscriptions and did not use his own monogram. Although the woodcuts are therefore unsigned, it is clear that Dürer made them because he mentioned them in a journal he kept while he was traveling in the Netherlands. He carried with him a stock of his own prints to give as gifts to patrons and friends or to use as barter in paying his expenses. He noted in his journal that in February, 1521, while in Antwerp, he "gave Master Dietrich the glasspainter an *Apocalypse* and the 6 *Knots*"; he did not say what he received in exchange. Ever since, these six woodcuts, along with the original Italian engravings, have been called the *Knots.* Often incorrectly referred to as lace or embroidery patterns, the *Knots* are made up of continuously intertwined cords in patterns too intricate for intarsia, soldered wire, or couched thread, unless very much enlarged. They may have been an intellectual exercise for Leonardo, who included mysterious interlaces in the branches of the trees he painted on the ceiling of the Sala delle Asse in the Castello Sforzesco at Milan sometime between 1496 and 1499.

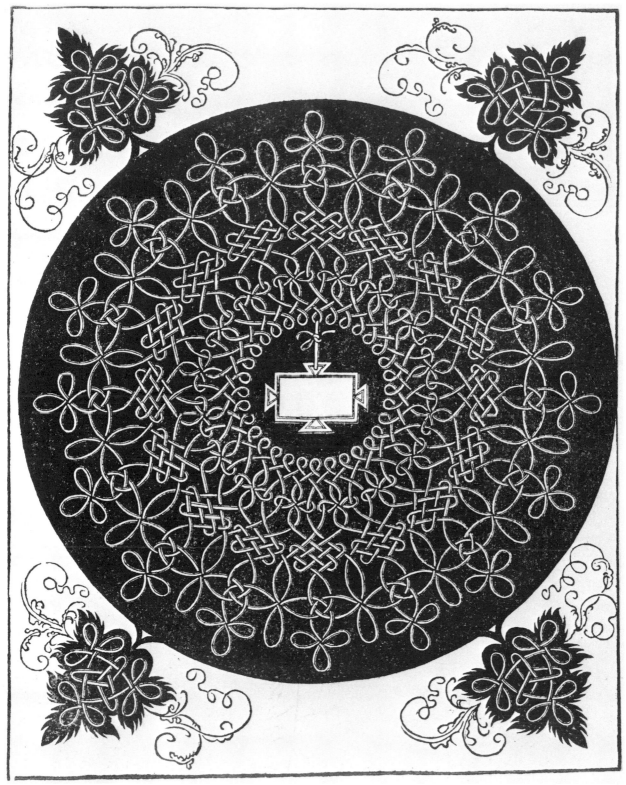

11

12

The earliest known printed Italian embroidery pattern book, Giovanni Antonio Tagliente's *Opera nvova . . . intitolata esempio di raccammi* (originally published in Venice in 1527, but represented here by the 1530 edition, which used the same woodblocks), is also the first dated pattern book known to have included moresques and interlaced cords or reed patterns. Dependent upon Near Eastern rugs, tiles, bookbindings, and metalwork, Tagliente's patterns also contain stylized flowers and laurel leaves and could be used for marquetry or painted decoration.

12. The international character of much Renaissance ornament was a natural result of the migration of artists, who were apt to go first to Italy to study and later from court to court seeking patronage. Because of the large production and the extreme portability of pattern books, ornament ideas traveled rapidly across Europe.

13. A drawing of great rarity meant to be engraved for publication is attributed to Master f, who probably worked in Venice in the 1520s and 1530s. Master f produced many strips of moresque ornament as well as a set of twenty moresque engravings. The title of the set explained that they were laurel leaves made in the manner of the Persians, Assyrians, Arabs, Egyptians, Indians, Turks, and Greeks and that they were for the use of painters, rug weavers, needleworkers, goldsmiths, stonecutters, and glasspainters. There was no mention of the designer or the place of publication, and no date. The copperplates found their way to the Antwerp shop of Hieronymus Cock, who is known to have been in Rome sometime between 1546 and 1548, and who may also have been in Venice. The son of the painter Jan Wellens de Cock and the brother of the painter Mathijs Cock, Hieronymus Cock was an engraver but is better known as a print publisher. An outstanding example of a sixteenth-century capitalist and entrepreneur, Cock hired others to make prints to be published and stocked in his shop, Aux Quatre Vents. A businessman, Cock had a large export trade, sending prints to Italy, France, and Germany. About 1550 Cock republished Master f's moresques, adding to the unsigned title plate his own name and address as publisher. Ever since, the set has been called *Cock's Moresque Book.*

13

14. This unsigned engraved pattern for embroidery is attributed to Master f on the basis of its similarity to his signed work. Although his letter *f* does not appear on anything except engravings, his patterns occur in woodcut copies published in Venice about 1530 in Giovanni Andrea Vavassore's *Opera noua universal intitulata corona di racammi* ("A new universal work entitled the crown of embroidery"), the first of a long series of copies published in Germany and the Netherlands.

15. Although this stylized leaf and branch pattern is labeled *Per Cappelli la meta* ("For half of a cap"), it looks more like an ironwork grille for a lunette-shaped window. Only at the bottom center does the pattern not support itself, and if a metal grille were forged according to this pattern, it might collapse. Because patterns were made for professional artisans, it is extremely unusual to find suggestions for use on ornament prints. This pattern dates 1540–50 and is signed by E.[nea] V.[ico], an engraver and numismatist who was born in 1523 in Parma and who died in 1567 in Ferrara, where he was antiquarian to Duke Alfonso II d'Este.

14

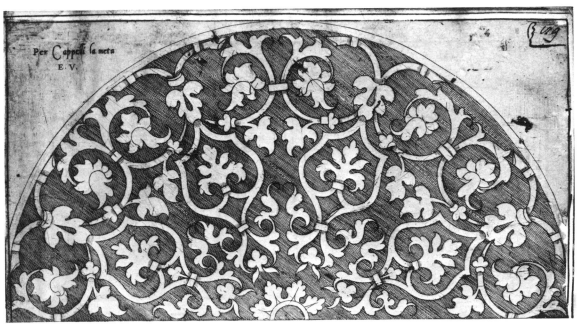

15

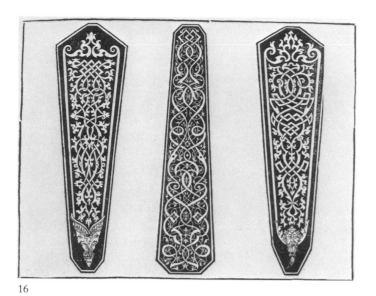

16

16–19. An ornament designer probably born in Switzerland about 1485 but working in Nürnberg, Peter Flötner signed his prints with his initials, a mallet, and a chisel. His work included woodcut designs for furniture—beds, a cradle, several elaborate doorways, and architectural capitals and bases. His only two engravings on metal, both jeweled pendants, bear his initials and a pair of crossed wood gouges. Flötner's signature with his woodworking tools and his many prints of carved wooden objects lead us quickly to the conclusion that he was a woodworker, inlayer, and cabinetmaker. Sometime before 1546 (when he died), he copied one of Master f's moresques. He made orig-

17

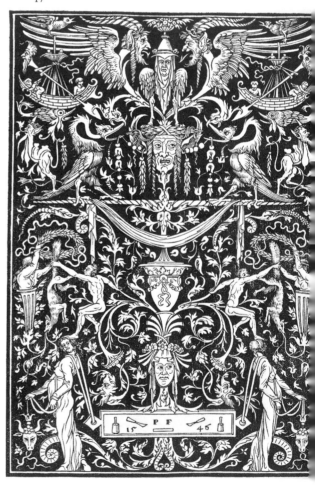

34

inal moresque designs, including some for daggers and sheaths (16), but none are dated, and whether he issued them as a pamphlet or sold them individually during his lifetime we are not sure. All we know is that in 1549, three years after Flötner's death, a woodcutter and publisher *(Formschneider und Verleger)* named Rudolf Wyssenbach (working in Zurich between 1545 and 1560) issued a set of moresques without a title but including Flötner's signed and dated grotesque (1546) (17). Extraordinarily rare, the Museum's impressions of the Wyssenbach pattern book survived only because very soon after the book's issue it was bound with a treatise on military exercises. There is no evidence that the patterns were ever used—they are undamaged. The blocks were reused by Wyssenbach in 1559 when he published a volume on Roman emperors by Jacob Gessner; wherever he found a bit of blank paper in the Gessner book Wyssenbach printed one of Flötner's moresques.

Because the patterns in the Wyssenbach book fall into two distinct varieties—first, the handsome but clumsily drawn and cut white patterns on black backgrounds (18), in the same style as Flötner's signed and dated grotesque, and second, the sophisticated, curvilinear black moresques on white backgrounds (19)—they seem to be the work of different men. The puzzle is further complicated by the close similarity of some black-on-white-ground patterns to those etched and published in France by Jacques Androuet Du Cerceau. Scholarly arguments concerning the identities of the designers abound and begin with the question: Did Flötner have anything to do with the black-on-white patterns, the only ones similar to Du Cerceau's? Since in neither case is an original publication date known, we may never discover whether the Wyssenbach woodcuts or the Du Cerceau etchings came first. A search for a common source, probably Italian, has so far proved fruitless.

18

19

20. What Balthazar Sylvius did in Rome as a student of Marcantonio's is not known. Some of the many engravings by Marcantonio's followers are surely by northerners, but none are signed by Sylvius, whose name was Balthazar van den Bos before being Latinized. Born in 1518 in Bois-le-Duc ('s Hertogenbosch), he returned from Rome to Antwerp in 1543 and worked there until his death about 1580. Unlike Marcantonio, his best-known engravings are ornament, especially moresque patterns. He made four sets of plates between 1550 and 1560, choosing for his most beautiful (1554) a title copied almost verbatim from plates produced some twenty years earlier in Italy by Master f and republished in Antwerp about 1550 by Hieronymus Cock: *Variarum protractionum forme, quas vulgo Maurusias vocant* ("Various protractions which in everyday language are called moresques"). For another set of moresques Sylvius borrowed, word for word, the same French title used in 1563 by Du Cerceau: *Liure contenant passement de moresques tresutile a toutes gens exercant ledict art* ("A book containing moresque trimmings very useful for all those carrying on the said art"). Although Sylvius copied titles, he did not copy designs. His plates were distinctly his own and included a large variety of shapes—rectangular strips, circles, lozenges, triangles, and medallions.

21–24. One of the most beautiful embroidery books ever made was published by Giovanni Ostaus, a German printer and publisher working in Venice. His little *La vera perfettione del disegno di uarie sorti di ricami* ("The true perfection of the design of various kinds of embroidery") of 1567 says that it was "fatto nuouamente per Giouanni Ostaus" ("newly made by Giovanni Ostaus"), but it contains embroidery patterns copied from

20

VARIARVM·PROTRACTIONVM · QVAS·VVLGO· MAVRVSIAS·VOCANT·OMNIVM·ANTEHAC· EXCVSARVM·LIBELLVS·LONGE·COPIOSISSIMVS· PICTORIBVS · AVRIFABRIS · POLYMITARIIS · BARBARICARIIS·VARIISQVE·ID·GENVS· ARTIFICIBVS·ETIAM·ACV·OPERANTIBVS· VTILISSIMVS·NVNCQVE·PRIMVM·IN·LVCEM· AEDITVS·ANNO·1554·BALTAZAR·SYLVIVS·FECIT·

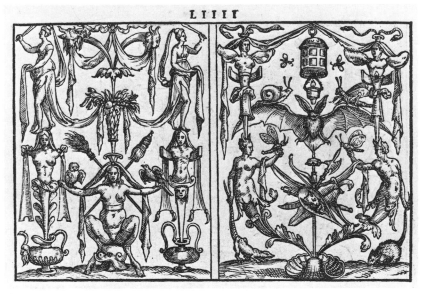

21

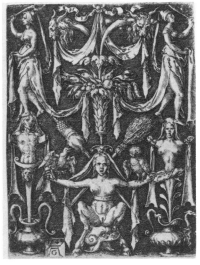

22

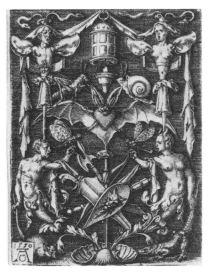

23

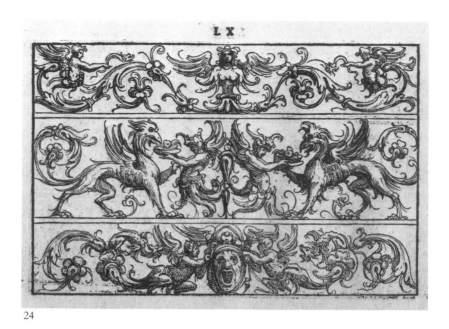

24

25

many sources. There are woodcut copies (in reverse) of Heinrich Aldegrever (born 1502, died sometime between 1555 and 1561) engravings of leaf ornament dating 1530–53, and of two Aldegrever grotesques of 1549 and 1550. There are half a dozen woodcut patterns after engravings by Virgil Solis, who lived from 1514 to 1562. Several pages of distinctive but unidentified grotesques, one of which has the signature S, are Italian in style. The S may be the mark of Giuseppi della Porta, called Salviati, whose name (the only artist's name in the book) appears on an illustration with a figural subject, not an ordinary embroidery pattern. In addition to the copies of German and Italian designs, Ostaus included several Netherlands landscapes and four illustrations of classical legends in the style of the Frenchman Bernard Salomon.

25. A pattern book for goldsmiths was designed by Georg Wechter, whose inscription on his title page, *Geörg Wechter 15 Maller 79*, shows that he preferred to think of himself as a painter. John Hayward (*Virtuoso Goldsmiths*, London, 1976, pp. 237–38) credits Wechter with the introduction of a new version of low-relief strapwork patterns that completely covered the surfaces of his cups, ewers, and other gold and silver vessels. Designs of this variety are included in the pattern book.

26–29. A complicated government project of 1515, the *Triumphal Arch* formed part of Emperor Maximilian's glorification of the House of Hapsburg and of his own achievements. There was a literary scheme by the author Stabius, an architectural plan by Jörg Kölderer, and an ornamental plan by Dürer.

Because of the size when assembled (approximately eleven by ten feet), as well as for reasons of patronage, the sections (192 blocks) were parceled out to many artists in Nürnberg and Augsburg. Dürer himself did very few, and his hand is easily recognized when the sections are looked at individually.

Dürer's most delightful contribution to the vocabulary of ornament is to be found in the details of the *Triumphal Arch*. Look, for example, at the double-tailed mermaids (a motif going back to Mesopotamia), partly human, partly marine sirens, hung up out of trouble, symbolizing by their chained and drooping presence the conquest of sin (26). Elsewhere (27) Dürer made a decorative pattern by repeating an everyday object: laced and tasseled cushions (like the draft-stopping *Fensterpolster* still in use in Austria a decade or two ago) fill the gaps where Maximilian's family tree, unlike the architecture of the arch, is not symmetrical.

To comprehend the significance of the details on Dürer's arch the viewer must know that pomegranates were Maximilian's personal device and are a symbol of fertility and unity. They appear at the top of the portal of *Lob* ("praise") and are accompanied by human heads blowing a stream of air—two of the four winds—scattering Maximilian's seed across the world (27). Laurel leaves, grapevines, lilies of the valley, and pea pods add emblematic significance to the base of the column with the three harpies, who were probably derived from earlier prints by the Italian Giovanni Pietro da Birago (76–87). What is the significance of the dead bird (28) hanging above the snail and the monkey? Why is the snail so large, and does it stand for slowness, sliminess, or timidity? Only a careful reading of Stabius's dusty text can answer these questions.

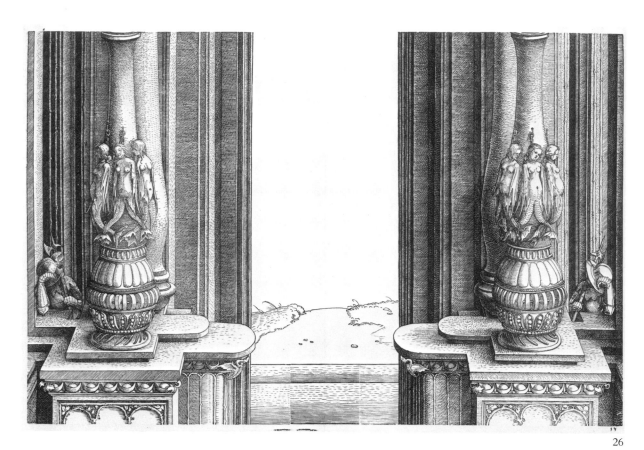

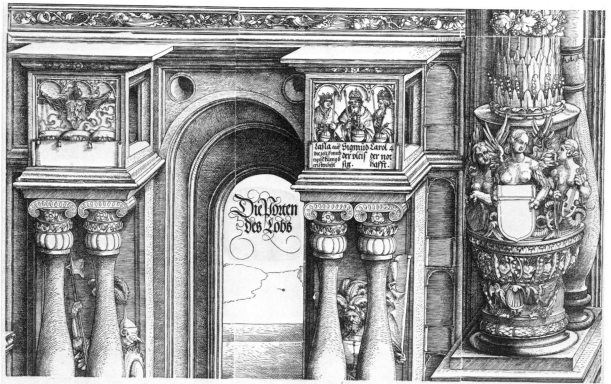

Die Porten des Lobs

Lasla auf Sigmud Carol 4
die zeit sines der vleis der not
regirt kungs erstenhait hafft.

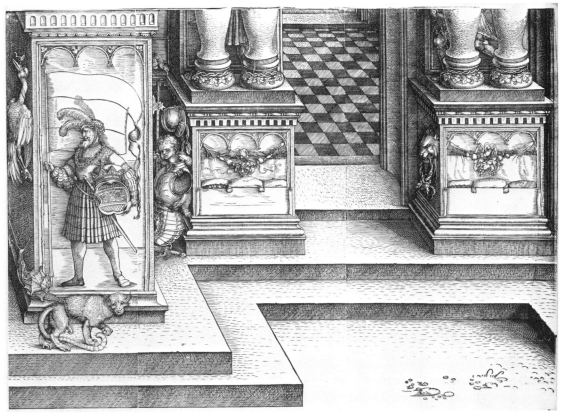

28

29

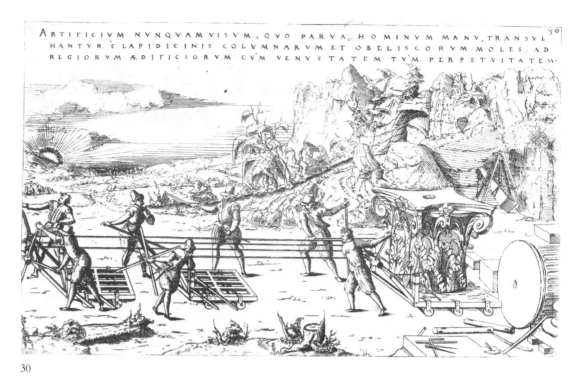

ARTIFICIVM NVNQVAM VISVM, QVO PARVA HOMINVM MANV, TRANSVE
HANTVR E LAPIDICINIS COLVMNARVM ET OBELISCORVM MOLES, AD
REGIORVM ÆDIFICIORVM CVM VENVSTATEM TVM PERPETVITATEM—

30

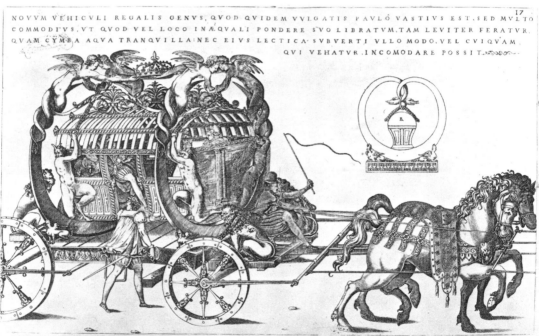

NOVVM VEHICVLI REGALIS GENVS, QVOD QVIDEM VVLGATIS PAVLO VASTIVS EST, SED MVLTO
COMMODIVS, VT QVOD VEL LOCO INÆQVALI PONDERE SVO LIBRATVM, TAM LEVITER FERATVR,
QVAM CYMBA AQVA TRANQVILLA: NEC EIVS LECTICA SVBVERTI VLLO MODO, VEL CVIQVAM,
QVI VEHATVR, INCOMODARE POSSIT.

31

30, 31. By no means the earliest fully illus- trated "how to" book (a writing book by Sigismund Fanti published in Venice in 1514 achieved that distinction), Jacques Besson's machinery book, *Theatrvm instrv- mentorvm et machinarum,* was illustrated by the French designer and etcher Jacques Androuet Du Cerceau, probably about 1569. Du

Cerceau was also an architect; therefore his plate 30, showing men transporting a large carved capital from a quarry and carving shop to a building site, is probably extremely accurate. Some of the machinery illustrated in the rest of the book evidently did not interest Du Cerceau, and it remains useful but unadorned.

On the other hand, a royal wagon is especially splendid. Not only is it carefully suspended to eliminate extraneous motion (Besson's idea), but the "commodious vehicle" is decorated with sphinxes, lions, and satyrs, as well as twisted-double-tailed, winged supporters closely resembling some in Du Cerceau's book on caryatids. Besson's popular book was printed so many times that

in the Museum's third edition of 1578 the plates show wear. A few of Du Cerceau's etchings had to be replaced, and these were engraved by René Boyvin, whose initials appear in the detail of the suspension, above the horses.

32, 33. A naive delight in machinery for its own sake is to be seen in a book by Agostino Ramelli, *Le Diverse et Artificiose Machine,* published in Paris in 1588 and illustrated by Jean de Gourmont the Second (fl. 1565–81). Gears provide the excuse for designing the revolving lectern (the better to read footnotes and to compare sources and various authorities) for use in a securely locked and bolted library reading room. The books were no

33

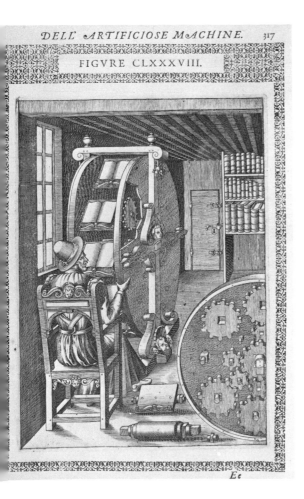

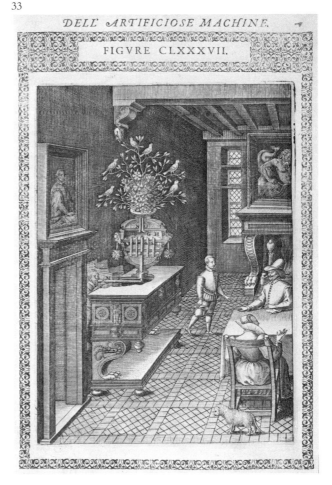

longer chained as they were in medieval libraries, but the reader could not leave until an attendant with a key arrived.

Another Ramelli conceit is a bush of singing birds—a wind and water machine—"a beautiful sort of vase which will give pleasure and contentment to everyone" except, presumably, the servant in the next room, whose job it is to blow through a connecting pipe to make the birds sing.

34. To decorate the title page of a book published in Augsburg in 1515, Daniel Hopfer combined leaf-masks in profile and full front with cornucopias, children, and ladies ending in leaves. Typical Renaissance motifs, they frame Frederick II and Ninus (fl. 1330? B.C.), founder of the Assyrian Empire, who has been dressed in fancy sixteenth-century German armor.

35. The mask of a true satyr—wicked, licentious, a tease, a bit vicious and amused—etched by Master AP in 1555 is the focus of a horizontal frieze of great simplicity. The satyr is flanked by wheat ears and eggs, and paired dolphins twined about a rudder and a trident. Although the emblems today no longer identify anything or anyone except marine abundance, the frieze remains a handsome filler for a horizontal space.

36. Akin in power and vitality to a Medusa head, this shouting mask of a horned satyr in a medallion could be used for a fountain. Of the many prints bearing the name of Antonio Salamanca (a print publisher and engraver who died in Rome in 1562), this is one of the few he himself engraved.

37. A complicated story of piracy indicates that pattern books of masks were in demand in more than one country in the sixteenth century and that the etiquette we today associate with copyright did not then exist.

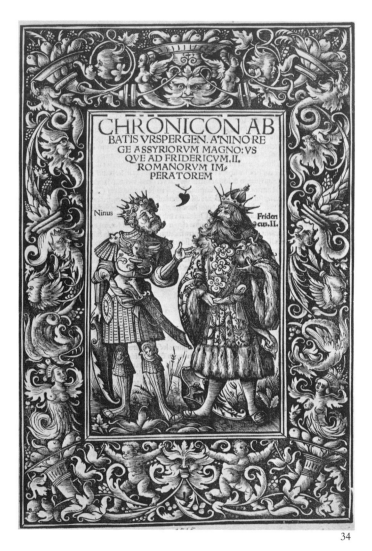

34

44

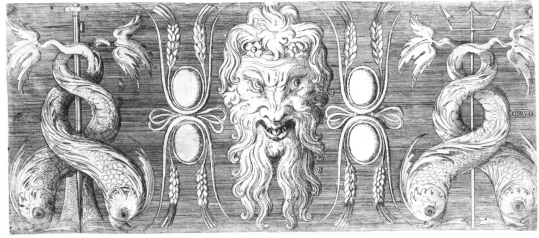

35

Cornelis Floris, in Antwerp, designed a set of grotesque masks about 1555 that were engraved by Frans Huys. These were copied by an unknown Italian who worked in the third quarter of the sixteenth century and signed his copies IHS (he is therefore often called the Master with the Name of Jesus). His set of copies, along with some of his original designs, was published in 1560 with a new title page on which is inscribed *Renatus B. fecit,* and the whole set has consequently been attributed to René Boyvin, who probably made only the title page. Whoever did what, this particular mask could not be less French, less like anything by Boyvin, or more like the work of Cornelis Floris (63, 70).

36

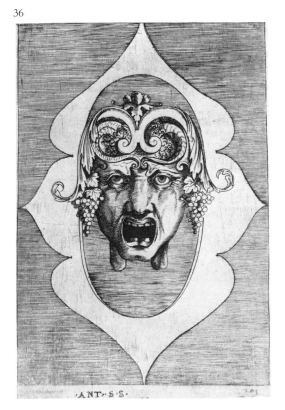

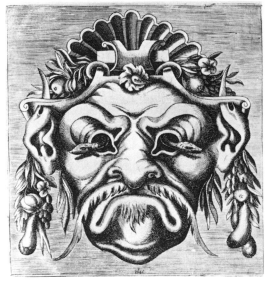

37

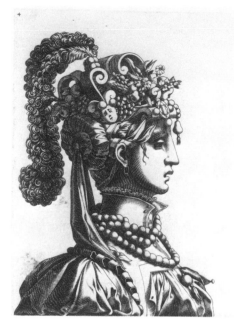
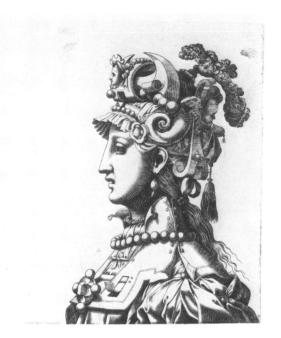

38

38. Elaborate headdresses to be worn over facial masks and used for masquerades were engraved by a Frenchman (formerly thought to be René Boyvin) after Rosso's designs. A stiff curving structure of cloth or leather is interpenetrated with strings of beads, flowers, fruit, hair, tassels, feathers, and a few masks of its own.

39. The tailpiece to Joseph Boillot's book of terms, *Novveavx Povrtraitz et figvres de termes pour vser en l'architecture . . .* (Langres, 1592), is an enigmatic sleeping female mask of great style, perhaps Boillot's own comment on his hilarious book (72–74).

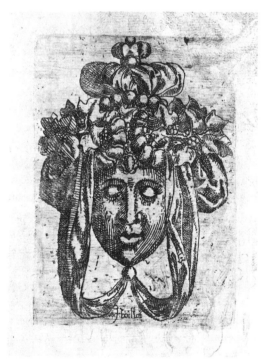

39

CHILDREN are extremely adaptable as ornamental motifs. Whether they are called cupids, amorini, amoretti, erotes, putti, cherubs, baby angels, baby monsters, heralds of arms, or genii, they can be forced into spaces of various shapes, given something emblematic to do, or allowed to be themselves. In the ornament prints of the sixteenth century, children can be found climbing leafy trellises (a theme popular in antiquity) or, having climbed, standing on towering candelabra looking proud. They can be piously angelic or mischievously naughty, aping their elders in occupations in which their elders are seldom shown. They play ball, run with pinwheels, dance, fight, play war games, frighten each other from behind masks, jump rope, ride on dolphins and monsters, pose with bears and lions, blow horns, and bang on drums.

Children as ornament appear more often in Italian and German designs than they do in English, French, or Netherlandish. Used a good deal in antiquity, they appeared less frequently in medieval times, but in the fifteenth century they flourished, proliferating until the mid-sixteenth century and then gradually disappearing.

40, 41. Two varieties of boys with wings were engraved by Hans Leinberger from Landshut sometime between 1510 and 1520. The baby angels carrying the instruments of the Passion as though they were taking part in an antique bacchanal or triumphal procession show that Leinberger knew the work of Mantegna, and that he could not imagine how to fasten wings on a human body. Feathers grow on the arms of the two amoretti in Leinberger's other engraving. They have been stringing peas on a cord and are ecstatically struggling with an oversized pea pod. Behind them a procession of turbaned riders crosses a bridge. An oval of giant pea pods and bouquets of pea blossoms frames this emblematic scene.

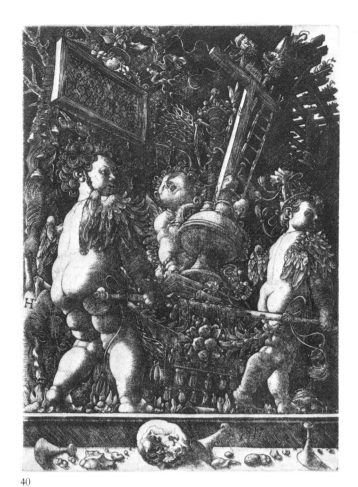

40

41

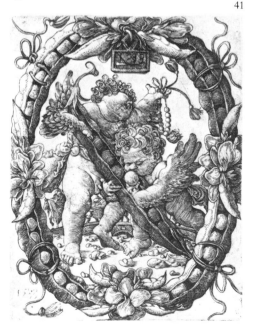

42

43

42. This endearing little back with the marvelously foreshortened legs belongs to a child preoccupied with a magical circular vine casting its shadow on the background and springing from what looks suspiciously like a chamber pot. If there is an emblem, it is not obvious, nor is the ornamental use to which this engraving could be put. Barthel Beham's tiny engraving was probably done about 1526.

43. Hans Weiditz, a book illustrator who was unidentified for several hundred years because he did not sign his work and because he worked for many publishers in different places—Augsburg, Strassburg, Nürnberg,

Mainz, Frankfurt, Landshut, Venice, and Paris—designed a delightful alphabet. Although it could have been intended for use as initial letters in books, no book containing this alphabet is known. Instead, the entire alphabet was cut on two woodblocks and printed on two sheets with the woodcutter's name and address, *Jost de Negker zu Augspurg,* printed at the bottom of the second sheet. The Museum's impressions have been divided by a former owner into eight strips of three letters each, and Jost de Negker's name has been cropped.

The beautifully proportioned letters are almost invisible because the eye looks past them to the antics of the children in the back-

ground. Two children in the letter Z hold aloft banderoles with the date, 1521.

44. Derived from a long series of antique monuments including sarcophagi, children holding garlands (a symbol of mourning) were a motif especially popular in the Renaissance. Garlands, festoons, and swags of fruit and vegetables appeared on tombs, in architectural friezes, and draped over ox skulls in imitation of classical antiquity. Another meaning was added when the children were turned into erotes for a set of tapestries for Pope Leo X, whose emblem, the lion, is over the central putto pretending to be king. The king indolently dangles two large keys, another papal emblem (the pope, as earthly rep-

resentative of Saint Peter, keeper of the gates of heaven, has two keys as a badge), while he puts his foot on the globe of the world.

A set of four prints was produced, perhaps in the 1530s, by the Master of the Die (his signature, a cube marked B, appears in the lower right), who engraved in his plate the information that Raphael invented it (lower left, • Rapha[el] • Vr[bino] • In[venit] •). Giorgio Vasari wrote about an exceedingly similar set, saying that it was designed by Giovanni da Udine, and scholars have debated the issue ever since. The four plates symbolize the four seasons and the four temperaments, but it is not obvious which season and which temperament this king with his court represents.

44

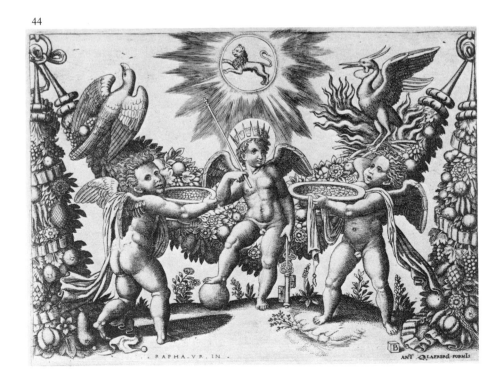

45. From a set of unnumbered and unsigned plates traditionally attributed to the Master of the Die, this one (dated 1532 in the upper right) with a poem may serve as a title page. There is no mention of the designer, and until 1966 Adam Bartsch's constantly repeated phrase "after Raphael" was unquestioned. In 1966, however, Konrad Oberhuber ("Obser-vations on Perino del Vaga as a Draughts-man," *Master Drawings* 4 [1966]: 170) attrib-uted the designs of this set to Perino del Vaga on the strength of a Perino drawing in the Uffizi. The unidentified author of the poem says that this sheet was made for artisans from paintings in Roman grottoes.

45

Il poeta el pittor Vanno di pare
Et tira il lor ardire tutto ad un segno
Si come espresso in queste carte appare
Fregiare dopre & dartificio degno

Di questo Roma ci puo essempio dare
Roma ricetto dogni chiaro ingegno
Da le cui grotte oue mai non saggior
Hor tanta luce a si bella arte torna

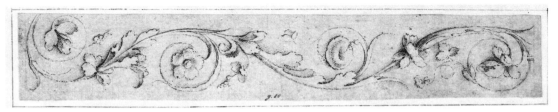

46

LEAVES have appealed as a subject for ornament more than any other single motif, for they are varied, easily stylized, and can be arranged to fit any space or combined with other motifs. They can fill empty spaces and disguise ugly transitions between figures and objects. They are sometimes emblems (laurel, oak, olive, fig) and as subjects do not offend anyone for religious reasons. But leaves are not especially exciting and sometimes not sufficiently interesting. Therefore they tend to acquire flowers, butterflies, rabbits, snails, birds, people, and monstrous creatures.

The Renaissance goldsmith and sculptor Benvenuto Cellini (1500–70) wrote in his *Autobiography* (trans. John Addington Symonds, London, 1888, vol. 1, pp. 77–78):

It is true that in Italy we have several different ways of designing foliage; the Lombards, for example, construct very beautiful patterns by copying the leaves of briony and ivy in exquisite curves, which are extremely agreeable to the eye; the Tuscans and the Romans make a better choice, because they imitate the leaves of the acanthus, commonly called bear's-foot, with its stalks and flowers, curling in divers wavy lines; and into these arabesques one may excellently well insert the figures of little birds and different animals, by which the good taste of the artist is displayed. Some hints for creatures of this sort can be observed in nature among the wild flowers, as, for instance, in snapdragons and some few other plants, which must be combined and developed with the help of fanciful imaginings by clever draughtsmen.

46. Of an ultimate simplicity, delicacy, and sophistication, this curving vine from fifteenth-century Italy is so balanced that it can be read vertically or horizontally. Only the shade lines (which go from upper right to lower left) tell that Mantegna, who was right-handed, expected this drawing to be seen horizontally. Mantegna sometimes designed gilt gesso frames for his own paintings, and the sculptural quality of this rinceau suggests that it may have been a study for a frame.

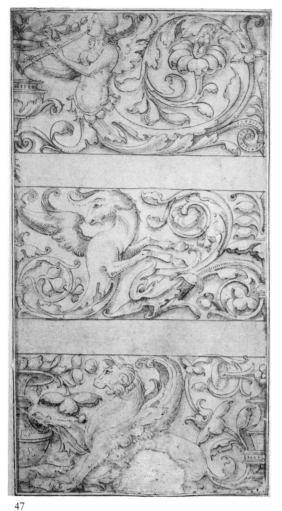

47

48

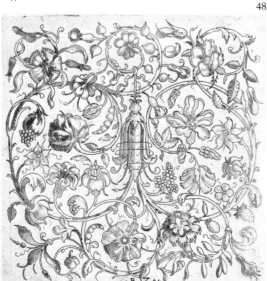

47. From the north of Italy comes this drawing of three friezes with vases, monsters, and rinceaux arranged in what amounts to a classical formula. The same designer, working about 1520, tried his hand at grotesques but did not add any new motifs (60).

48. Tied to and hanging from one of its own tendrils, Bernhard Zan's flowering vine curving symmetrically through a rectangular space defies botanical description; it is a goldsmith's design. Although it could be used for embroidery, a needlewoman in search of a pattern would probably never find this one since it was published (in 1581) with designs for cups, beakers, and other goldsmiths' work.

49. Daniel Hopfer's Gothic stone tracery with birds completely fills its rectangular frame with balanced Renaissance curves of acanthus-oak-holly branches from which acorns, stylized into little silver bells, grow upward. By 1530 Hopfer's etching had been copied in reverse by the Venetian Nicolo Zoppino in a woodcut illustration for an embroidery pattern book.

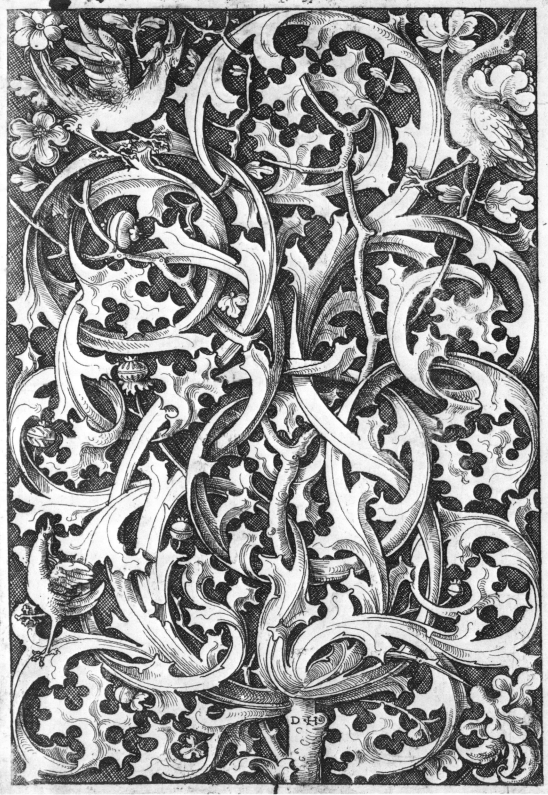

49

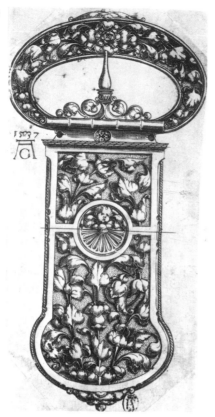

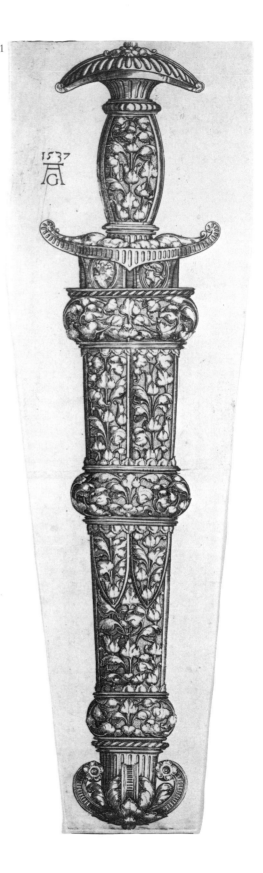

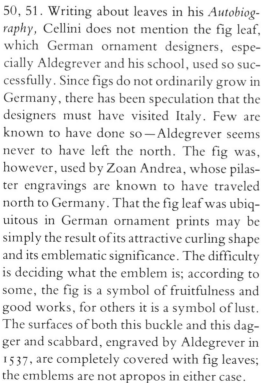

50, 51. Writing about leaves in his *Autobiography,* Cellini does not mention the fig leaf, which German ornament designers, especially Aldegrever and his school, used so successfully. Since figs do not ordinarily grow in Germany, there has been speculation that the designers must have visited Italy. Few are known to have done so—Aldegrever seems never to have left the north. The fig was, however, used by Zoan Andrea, whose pilaster engravings are known to have traveled north to Germany. That the fig leaf was ubiquitous in German ornament prints may be simply the result of its attractive curling shape and its emblematic significance. The difficulty is deciding what the emblem is; according to some, the fig is a symbol of fruitfulness and good works, for others it is a symbol of lust. The surfaces of both this buckle and this dagger and scabbard, engraved by Aldegrever in 1537, are completely covered with fig leaves; the emblems are not apropos in either case.

52. While he was writing about leaves (see page 29), Cellini might have been looking at a set of plates of acanthus ornament engraved by Enea Vico, probably in Rome in the 1540s. Several of the plates (not illustrated) contain relatively simple acanthus rinceaux "curling in divers wavy lines," but a variant with an openwork cornucopia of leaves and fruit has in its upper-left corner a leaf so irresistible that Vico was tempted to add a face. Mon-sters became even more fascinating than the leaves in which they lived.

53. Vico has here turned a whole rinceau into a monster — a rinceau-ram — with a small leaf-animal and a serpent. Meant to be doubled, many of Vico's friezes have their centers — a mask, an ox skull, a vase, a candelabrum, or a whole acanthus plant — at one edge.

52

53

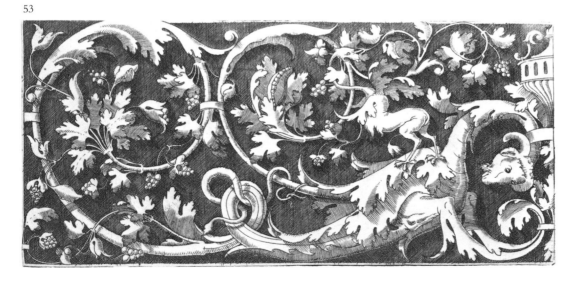

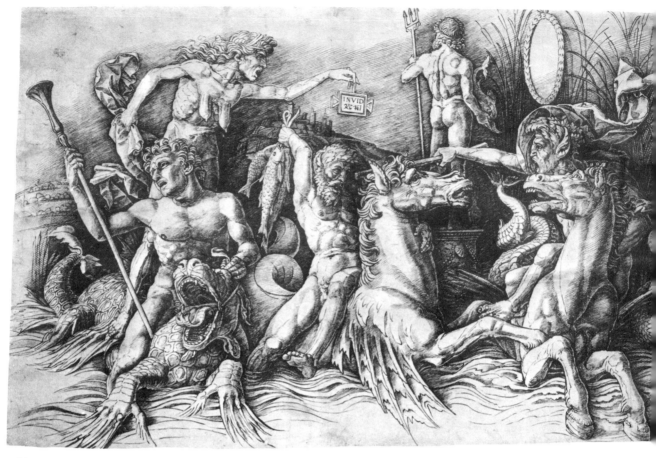

54a

54ab, 55. Andrea Mantegna's engraving *The Battle of the Sea Gods* (54ab) inspired many Renaissance ornament printmakers and craftsmen. Printed from two plates forming a continuous frieze, it was derived from antique sources. Sea monsters appear on antique sarcophagi and on architectural friezes, but it was Mantegna's strong images of fighting sea monsters that captured the eye and the imagination of artists like Dürer, who drew a copy of the right half of the print in 1494. Hans Sebald Beham used the old triton with two fish in a wallpaper frieze (4) and the sea monster with the bone in his right hand in an undated engraving of Cimon and Pero. In 1537 the same monster from the right half was adapted by Master CG (55), probably from Beham, not Mantegna.

56

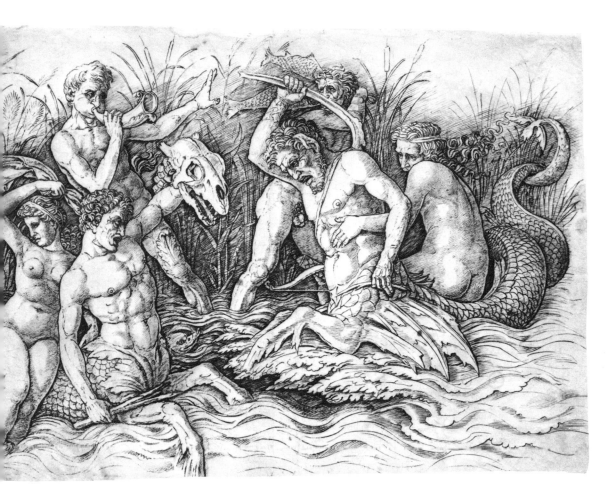

4b

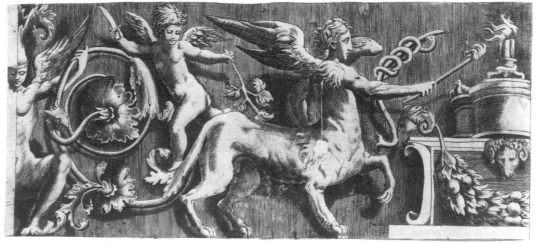

56

56. A winged and squatting figure with leaves for feet grasps the acanthus-rinceau tail of a young centaur lighting his torch at an altar. Those of us who have only a rudimentary knowledge of antique sculpture must agree that this engraving, made about 1550, is "truly after the antique," as Bartsch says. Those of us who realize how often Renaissance ornament was designed with the proper ingredients in imitation of the antique wish he had told us exactly which antique frieze he had in mind.

57

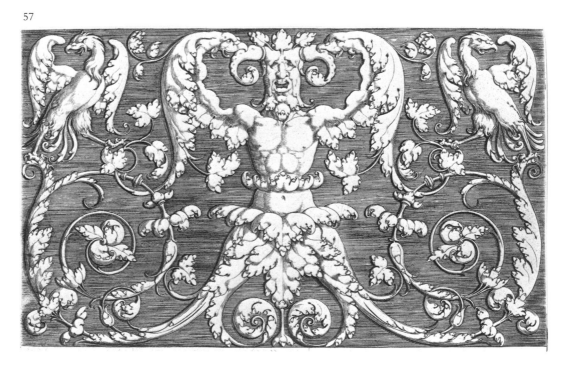

58

57. A horned half-leaf-man, with wings for arms and biting birds' heads for hands, stands on a single bird's foot and is accompanied by two large angry birds. The unknown designer of this distinctive style is Master GI, a Dutch ornament engraver who worked between 1522 and 1531 (90). This symmetrical monster forms an allover pattern that is useful for metal or for wood carved in low relief. If he forms an emblem—with his bird hands biting his own horns—it is not readable.

58. Once Gothic letters were out of style, designers produced a variety of new alphabets. Early-sixteenth-century ones by Italians were inevitably based on antique Roman ones. Luca Paccioli, working partly after Leonardo, produced the first printed book on proportion in 1509. It contained the original alphabet now used by the Metropolitan Museum in its monogram. Dürer's book on proportion (1525) showed his interest in alphabets, and it inspired many artists and calligraphers to design all kinds of alphabets. Even embroidery books and goldsmiths' pattern books contained alphabets, which varied in every way—purpose, size, design, and taste. There were alphabets composed of human figures posturing to form letters, there was at least one pornographic alphabet, and there were grotesque alphabets. The latter are represented here by the letter S, engraved by Jan Theodor de Bry for *Nova alphati* [sic] *effictio historiis,* designed by his father, Theodor de Bry, and published in Frankfurt in 1595.

58

BECAUSE of the confusion in terminology, distinctions between *arabesque* and *grotesque* depend upon where and when the observer lived. Arabesque implies that something is in the style of the Arabs, which does not appear to be the case in most of the designs today called arabesque. Grotesque too has changed its meaning over the years and no longer signifies the style of Roman painting found in the vaults (grottoes) of Nero's palace, the Golden House. Grotesque by today's definition is apt to assume the meaning of fantastic. Instead of delicate garlands supported by putti, small temples with altars, minimal military trophies hanging from long ribbons, all balanced in fairly empty spaces, grotesque today summons an image of an assemblage of mismatched ingredients and outrageous juxtapositions of totally dissimilar objects, with little or no empty space.

For me, if for no one else, number 13 is an arabesque, number 57 is a grotesque in sixteenth-century imitation antiquity, and number 59 is a grotesque as we think of it today.

59. An unknown Italian engraved a set of about twenty plates sometime between 1530 and 1540, which he entitled *Leviores et (vt videtvr) extemporaneae pictvrae qvas grotteschas vvlgo vocant,* or "Light and (as it can be seen) extemporaneous pictures which in everyday language are called grotesques." He seems to have seen the Golden House of Nero but definitely takes credit for having created his own variations on a theme. His work was copied in reverse by Enea Vico, who was eighteen years old in 1541 when the copies were published by Vico's teacher, Tommaso Barlacchi. Barlacchi printed so many impressions of these copies that today some print collections identify the *Leviores* as the work of Vico.

59

Since the designs are more suitable for wall
decoration than anything else, tracing their
influence on ornament is difficult. However,
it is easy to see that Du Cerceau knew them.
Although Du Cerceau seldom copied ex-
actly, he did so in this case, reducing the size
for his set of *Petits Grotesques* (1550); he had
already adapted many other motifs from the
Italian set for his *Grands Grotesques* (1566).

60. Six early drawings contain familiar mo-
tifs—candelabra, vases, acanthus rinceaux,
monsters both human and animal, half of a
winged bull en face, and so on. Finding out
who drew them is enormously difficult. In
Christ Church, Oxford, there are two draw-
ings by the same hand and with the same
monogram, VR, which was transcribed by
their eighteenth-century owner as Vincenzo
Rondinelli. James Byam Shaw, who cata-
logued the Christ Church drawings, found
no record of such an artist, yet he felt that the
monogram was a signature and that the artist
may have been a majolica painter. The rectan-
gular shape of the Metropolitan Museum's
drawings makes it doubtful that these are ma-
jolica designs. VR with a terminal flourish is
very probably the signature—initials and pa-
raph—of a collector.

At the left of the drawing illustrated, near
the number 791 (written by a dealer or a for-
mer owner), is *Decio*. Since there was a
Milanese family of artists by that name,
A. Hyatt Mayor (who purchased these draw-
ings for the Museum) thought that perhaps
our drawings were by a member of the Decio
family. The most likely candidate is Giovanni
Antonio da Decio, goldsmith, who worked
on a reliquary for the Certosa of Pavia in
1495, but there is no evidence of any connec-
tion between this Decio and our drawings,
which probably date about 1520.

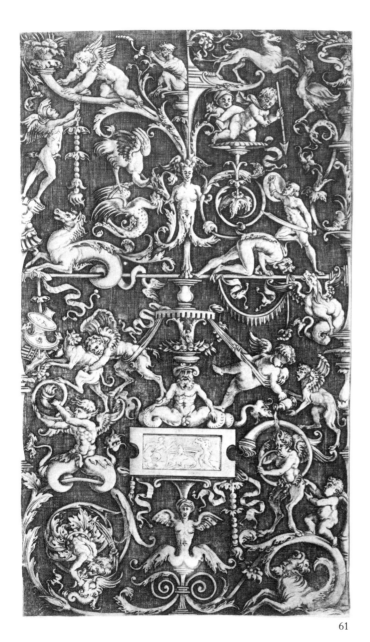

61

61. A symmetrical composition with a few variations from which the client could choose qualifies as grotesque but is completely different from the *Leviores* (59). Monsters of all varieties—half-human or half-animal—support an impossible structure or balance on a vine or carry on some strange and unrelated activity. On a shield in the trophy at the left are the initials V A, which in reverse are those of Agostino Musi, called Veneziano, who made this plate (said by Bartsch to be after Raphael) about 1520. Veneziano knew how to engrave letters so that they would come out properly in spite of the reversal inherent in printing an engraved copperplate; therefore it is surprising to find V A instead of A V. Because Oberhuber (*Renaissance in Italien 16. Jahrhundert Werke aus dem Besitz der Albertina,* Vienna, 1966, p. 106, no. 150) records an impression in Vienna on which the monogram is A V, it is probable that our impression is a sixteenth-century copy, perhaps by the same unknown engraver who made a reverse copy of another Veneziano grotesque (62).

62. Veneziano worked in Rome and Florence from 1516 to 1536, with the exception of 1527, when he fled from the sack of Rome. A student of Marcantonio's, Veneziano engraved some fifty-seven ornament plates in addition to his figural subjects. Without identifying the objects, Bartsch listed twenty-two of the fifty-seven as being after the antique—presumably Roman sculpture, bronzes, or paintings. The rest of the fifty-seven (architecture, vases, and panels of ornament) were after Sebastiano Serlio, Raphael, and Giovanni da Udine. The implication is that Veneziano was not an ornament designer but was simply engraving the work of others. A symmetrical grotesque, this design is after an unknown work by Raphael and is composed of favorite motifs—animal legs, ox skull, shouting mask, paired harpies and satyrs, all surmounted by half of a bull en face.

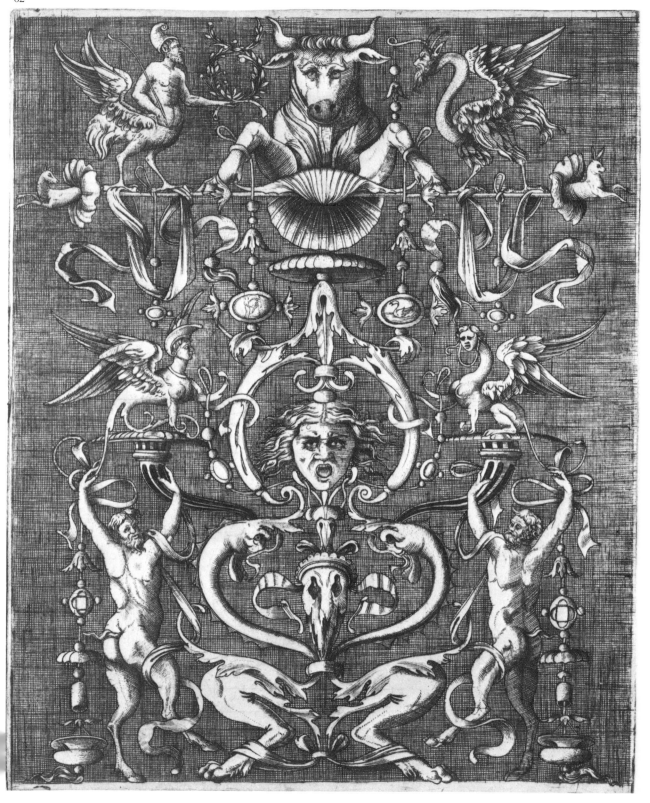

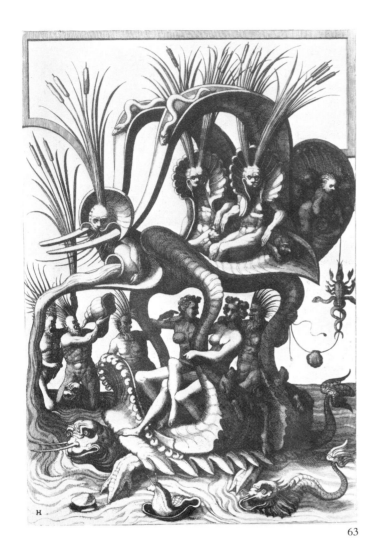

63

63. An architect and sculptor, Cornelis Floris had little time to devote to the tedious technique of engraving. Consequently, his grotesque designs were engraved for him by one of the brothers Duetecum. Although Floris had been to Rome, as had his publisher, Hieronymus Cock, he produced grotesques unlike anything that could be seen in the grottoes. His twelve plates, *Veelderleij veranderinghe van grotissen ende compertimenten* ("Many variations of grottoes and compartments"), published in 1556, include several similar to the one illustrated here, in which the "ear muscle" style of fifty years later is already evident. Accompanied by male marine creatures who have hair made of reeds, two women ride on the back of a monstrous turtle with a dolphin's tail. A scaffolding of horny shell provides some of the passengers with grandstand seats. The lion-faced men with bullrush antennae have face-framing collars like that of the turtle, which is perhaps a papier-mâché carnival wagon. Floris's inventive nightmares may have inspired the "flamenco" designer of the Museum's so-called *Spanish Grotesques* (65–67).

64. Jan Vredeman de Vries, who was trained and influenced by Cornelis Floris, made ornament designs of all sorts —caryatids, tombs, furniture, grotesques, perspectives, gardens, fountains, architecture. Because some of his designs are so atrocious, it is clear that he was occasionally more interested in selling printed patterns than in making works of art. He traveled a good deal in search of employment, and according to the architectural historian Henry-Russell Hitchcock, his designs of ornamented scrolled gables were responsible for the dissemination of that motif across northern Europe.

65–67. A riddle waiting to be solved is the identification of twenty-two sheets of varying sizes from a sketchbook of grotesque designs with Spanish inscriptions. The designs

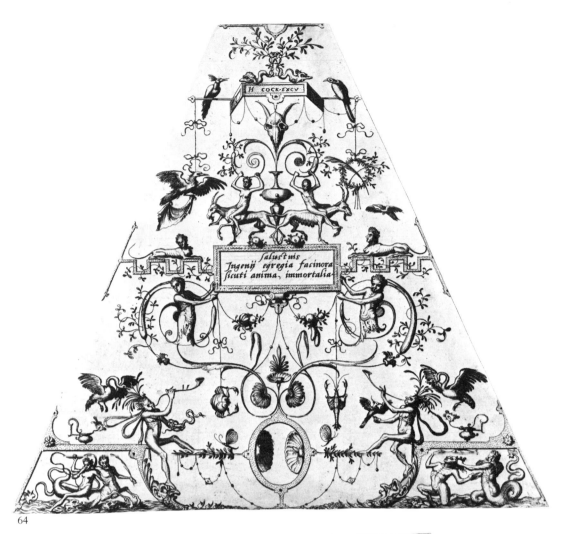

64

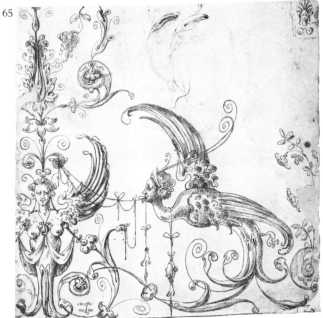

65

65

fall quite clearly into two groups. Many in the first group are labeled *Julio* or *Zulio,* have color notes, and closely resemble the designs by Raphael in the Vatican Loggia. One (not illustrated) includes the Roman letters S.P.Q.R., which are more likely to be found in Rome than in Spain. The color notes are either directions from the designer to the painter-decorator on the scaffold or an aide-mémoire of an observer, perhaps a Spanish artist in Rome. There is almost nothing complete in our sheets. Presumably a designer would give the painter a plan for an entire wall or ceiling, or at least a quadrant to be tripled; color notes seem hardly enough to bind together isolated motifs. No program is apparent in these twenty-two sheets, nor is one evident in other drawings from this group, which are in Michigan and Paris.

The second type of design is labeled *flamenco,* with no other description or color note, and is composed of creatures with shells and strapwork in the Antwerp style of Cornelis Floris (63).

66

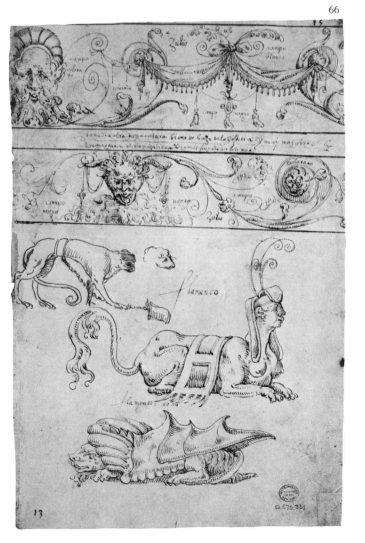

66

68. A Florentine artist and craftsman named Domenico del Barbiere (who worked with Rosso in France in 1537–40 on the palace of Fontainebleau) made a set of grotesque designs for wall decoration. Very different from the wall decorations on which he must have worked as a *stuccatore,* these are not high-relief strapwork and human figures framing paintings (159). Rather, they are flat and have a good deal in common with the designs that were then being painted on the walls and ceilings of Italian palaces in imitation of the antique. Entirely unlike this set, which may have been made simply to show the latest Italian fashion, the rest of Domenico's prints are extremely bold and demonstrate that he saw with the eyes of a sculptor. Illustrated here by Jacques Androuet Du Cerceau's reverse copy is a lunette with familiar antique motifs—victories in the triangular corners, a central panel with a triumphal procession, masks, swans, a Greek meander pattern, the cobweb shape of a Roman jalousie, and half-leaf-people with monsters.

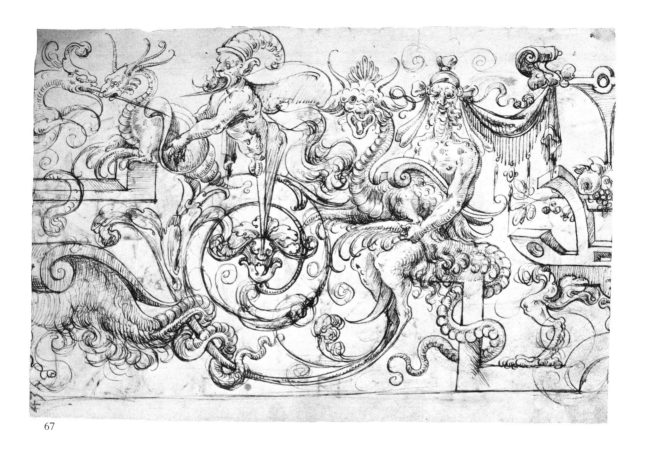

67

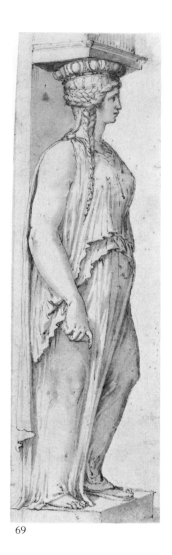

69

CARYATIDS, atlantes, and terms, familiar from Roman architectural sculpture, were ubiquitous in the Renaissance as vertical decorative motifs. Usually three-dimensional architectural ornament, they occasionally were only painted on facades around the doors and windows of mansions. They were used on wooden furniture, bronze andirons and door knockers, iron signboards, carved stone tombs and monuments, jeweled caskets, and rings. The decorated title pages of books, especially those printed in Lyons, were filled with them.

In Roman terminology caryatids were human female supports and atlantes human male supports, both slaves, Vitruvius tells us, condemned to hold up heavy weights. Title pages of sixteenth-century pattern books referred to them as caryatids or terms and created further confusion by omitting the word atlantes and making no distinctions of sex or purpose. Terms (from Terminus, the god of boundaries, and in classical antiquity never female) were in the Renaissance no longer merely freestanding, half-human male boundary markers but usually had the caryatids' function of supporting something and were often female. Designers produced wilder and wilder conceits. Caryatids became too slender to be of structural use; they turned, twisted, extended their hands, and wore fantastic projecting drapery easily chipped and broken. Whether they were called caryatids or terms, they supported weights incongruously resting on feathers or baskets of flowers and fruit, their bodies standing on ropes, mermaid tails, or German drinking glasses.

69. A caryatid drawing reminiscent of the antique sculpture at Hadrian's villa at Tivoli

is drawn in the manner of Pirro Ligorio (1500–83), who was put in charge of the Tivoli excavations by Cardinal Ippolito II d'Este. It shows a truly architectural lady whose hair strengthens the narrowing support at her neck and who has nothing that can break off except her nose, chin, and index finger. Ligorio was an architect, a collector, and, after 1567, official antiquarian to Duke Alfonso II d'Este in Ferrara, filling the position left vacant by Enea Vico's death. Ligorio's record drawings, which for many years caused scholars to think of him as a faker of antiquities, are now thought to contain his reconstructions, however fanciful, of damaged pieces.

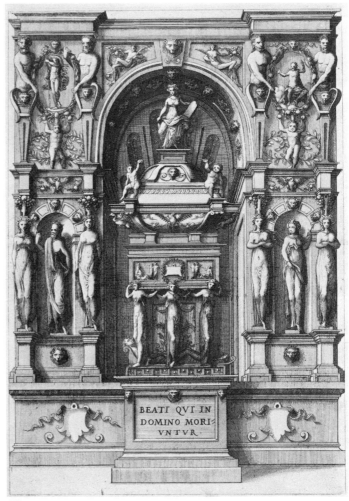

70. Cornelis Floris based a good many of his ornament designs on the antiquities he saw in Rome, but it is in their departure from the originals that their real interest lies. Floris's distortion of an antique motif can be seen in the extremely attenuated caryatids on this monument. Starting with a Roman triumphal arch, Floris changed the proportions, closed the arch, raised the structure by means of a pedestal, and embroidered the facade with ladies, fruit, garlands, masks, and children. *Beati qvi in Domino morivntvr* ("Blessed are they who die in the Lord") is the biblical inscription on the pedestal, but there is nothing else religious or even identifiable on the monument. Who are the waving children and the lady holding a tablet, all seated on the sarcophagus, and what is the meaning of the allegorical figures in the niches? Is the figure enthroned on the clouds in the upper-right medallion God the Father or Jupiter? After considering the ambiguities one can only conclude that this is a suggestion for a fashionable tomb.

70

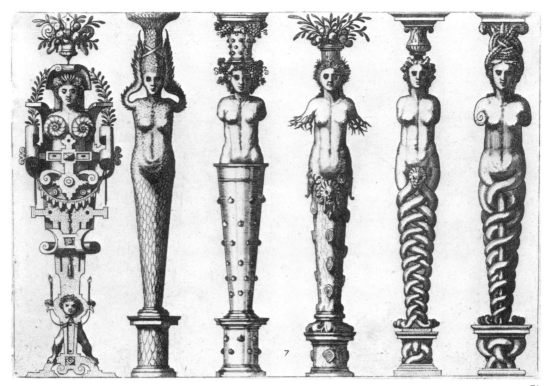

71. Designing a pattern book for craftsmen *(hantwerkers)*, Jan Vredeman de Vries noted in explanatory Latin and Flemish titles (there is no text) that caryatids and atlantes in everyday language were called terms. He said that his terms were in the style of the five orders of architecture (Doric, Ionic, Corinthian, Composite, Tuscan) and were useful for stonecutters, cabinetmakers, glasspainters, and all handworkers in the arts. Plate 7 does not indicate to which of the five orders these female terms belong.

72–74. In 1592 Joseph Boillot of Langres, who described himself as "contrerolleur pour le roy au magasin & grenier a sel" (which evidently means that he was an artillery officer and engineer), had a book published entitled *Novveavx Povrtraitz et figvres de termes pour vser en l'architecture: composez & enrichiz de diuersité d'animaulx, representez au vray, selon l'antipathie & contrarieté naturelle de chacun d'iceulx.* Boillot's idea seems to have been to show terms of animals, each including an enemy of the animal. For example, the horse term, which Boillot thought suitable for the decoration of either a facade or portal of a stable, wears a feather headdress and a tasseled cape; an ostrich stands in front. Boillot used the ostrich, he says, because it looks like a camel, and camels are enemies of horses. Tigers do not like sudden loud noises; therefore the tiger term is covered with bells, trumpets, and drums. The bull term wears flowers in its horns and a puffed silk cloak; its enemy is the courageous crow.

A portrait of Boillot in the front of the book shows him as a sour-looking individual who just might have taken himself seriously. However, the fatuous expressions on the animal terms in almost every case, considered with both the utter balderdash of the text and the sleeping female mask that was used as a tailpiece (39), make the book a sophisticated jab at architectural designers and decorators.

B iij

E

J. baillot

72

73

74

75

75. Atlantes are reduced by Vredeman de Vries to armed but armless soldiers, each with a single leg and foot. Stranger armor has never been seen—a single tasset defends the single thigh, a chain-mail skirt hangs out over the hips, breastplates are made with small squares ridged to catch, not deflect, pointed weapons, and articulations curve in opposition to human movement. No one who had the right to wear armor would have ordered such a tomb.

76–87. For more than fifty years these twelve engravings were inappropriately labeled arabesques by the Metropolitan Museum. Although today it is considered somewhat disgraceful to be a purist, it must be said that Arabs would not recognize these designs as their own: they are Renaissance Italian inventions based on antique Roman sculpture. The more than two dozen motifs in these twelve strips were already in the vocabulary of ornament when the miniature painter Giovanni Pietro da Birago (formerly known as the Master of the Sforza Book of Hours) assembled them as vertical designs. There is no tracing the motifs back to their beginning with any accuracy, but we do know that they went via Birago's prints (made between 1505 and 1515) to contemporary France. Several are to be found in the lower part and on the doorjambs of the choir screen in Chartres Cathedral, clearly dated 1526, and others were carved on the choir screen in the chapel at Gaillon, part of which is now in the Museum. Three of these candelabra designs by Birago were engraved by Zoan Andrea, who signed them with his initials. In the absence of Birago's name as either designer or engraver of the other nine prints, Zoan Andrea was given credit until the twentieth century for designing as well as engraving all twelve panels.

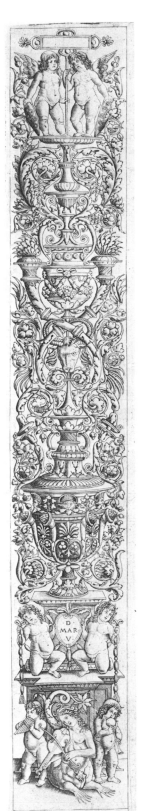

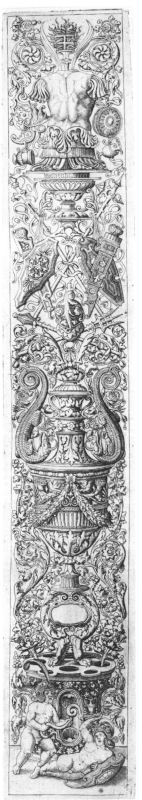

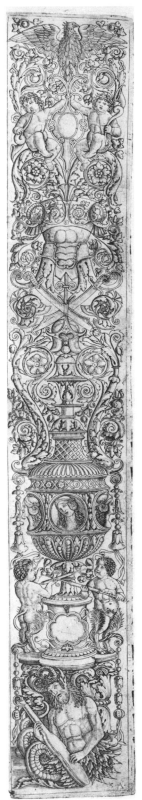

76

77

78

79

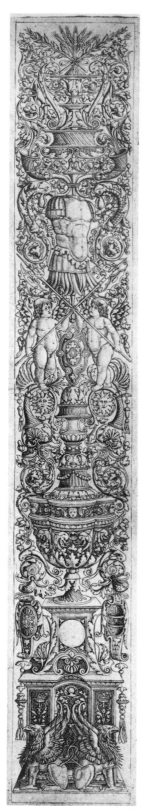

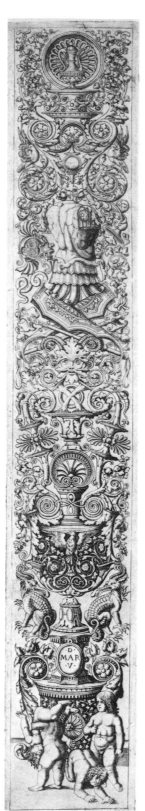

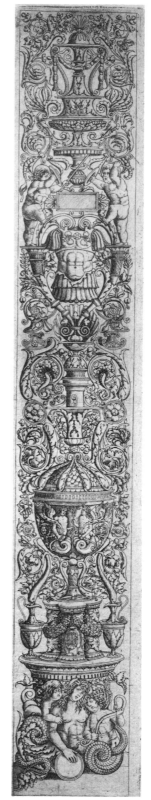

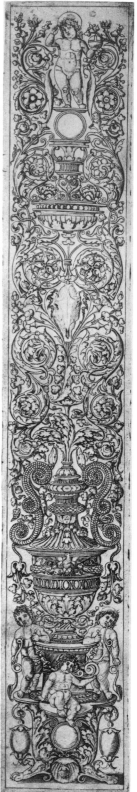

80 81 82 83

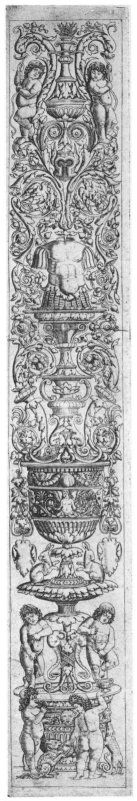

84 85 86 87

88

89

D H

88. A fragment of a larger plate, this candelabrum was engraved in the Florentine Broad Manner (which imitates drawing) by Francesco Rosselli sometime around 1470. Rosselli was a miniature painter familiar with the use of candelabra to decorate the borders of book pages. From a family of painters—his brother was Cosimo Rosselli—he must also have known the painter's framing device used to separate a series of wall paintings by means of pilasters decorated with candelabra and garlands. He made this unsigned print—and probably also the unidentified sheet (5)—for coloring, cutting, and pasting as a frame on the edges of other prints. An inventory of his son's shop in 1528 speaks of the father, Francesco, as a printer and mapmaker and lists a great stock of his prints along with apparently unrelated miscellaneous goods and novelties.

89. In Augsburg, the armor-etcher and print-maker Daniel Hopfer knew and copied late-fifteenth-century Italian designs, especially those by Giovanni Antonio da Brescia. Hopfer's sons Jerome and Lambert also copied early Italian ornament prints. The sources of these two candelabra have not yet been found; perhaps Hopfer only selected bits from other people's prints and rearranged them. The classical, rectangular pedestal panel and the large, simplified elements of the candelabrum on the left contrast with the grotesque Renaissance assemblage on the right. Hopfer was thinking in only two dimensions, as the flames, windblown hair, and smoking profile masks indicate.

90. A vertical ornament in the candelabra style terminates Master GI's decorative setting for the head of a warrior in a circular frame. How could this design be used? The warrior appears as though inside a porthole pierced in a wall decorated with metal filigree. The nude man with ass's ears stands on a leafy vine, holds a flower vase on his head with one

90

hand, and points with the other to a male mask also with ass's ears. A pair of monstrous birds and paired lion masks flank the candelabra motif above; below is a skull. Both the meaning of the emblems and the purpose of the object are a mystery.

91

91. A Parisian book illustrator probably trained in the shop of Geoffroy Tory used an altar or tabernacle frame (dated 1537 on its base) for this woodcut illustration of the Annunciation to the Shepherds in a Book of Hours. Completely architectural in character except for the leaves and bands below, the frame is an adaptation of a Roman triumphal arch, with a coffered barrel vault enclosing the scene. This framing device had been used by painters for at least a century. Masaccio, for example, had used it in 1427 for his fresco of the Trinity in Santa Maria Novella in Florence. The vault with the spandrels containing encircled heads was a favorite Renaissance form and appears on various sixteenth-century objects in the Museum, notably two German stove tiles by Hans Resch and a high-backed French armchair (not illustrated).

92. Hans Holbein the Younger designed an architectural framework for a full-length portrait of an elderly Erasmus of Rotterdam, who stands with one hand on the head of a term, Erasmus's personal emblem of death. The arch is decorated with fruit garlands, people holding cornucopias, a lion mask supporting a strapwork cartouche with Erasmus's name, and two terms functioning as atlantes. Holbein, who was German, used the same Italian motifs then being painted and carved (about 1540) in France in the palace of Fontainebleau.

78

ER · ROT ·

TERMINVS

Pallas Apellæam nuper mirata tabellam,
Hanc ait, æternum Bibliotheca colat.
Dædaleam monstrat Musis HOLBEINNIVS artem,
Et summi Ingenii Magnus ERASMVS opes.

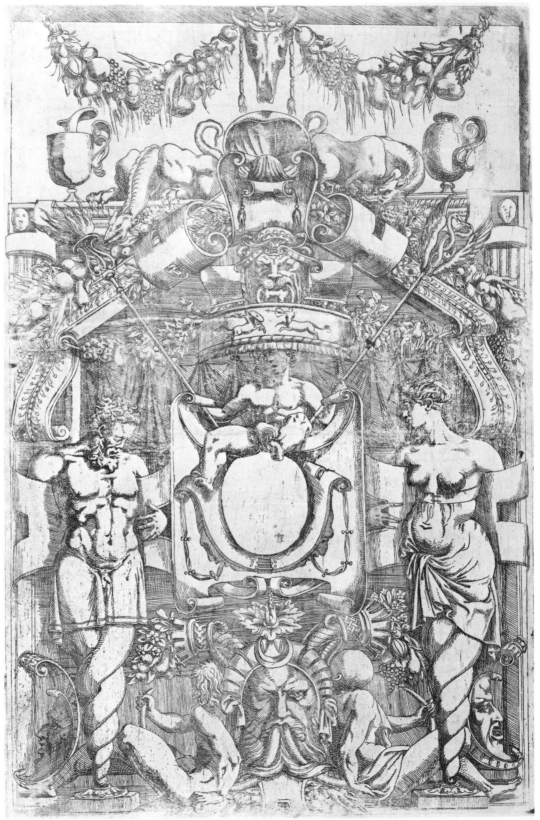

93. Filled with classical motifs, this strapwork cartouche by Antonio Fantuzzi is about as anticlassical as it can be. Masks, vases, garlands, an ox skull, cornucopias, male and female terms (female terms were nonexistent in Roman times), and a central figure holding a torch and a winged staff with entwined snakes (perhaps derived from Hecate, who stood guard with two torches at the doors of private houses in antiquity) have all been assembled with a framework of curving bands. Fantuzzi was one of the Italian artists and craftsmen who worked in France in the 1530s and 1540s decorating the palace of Francis I at Fontainebleau. He usually worked under the direction of Primaticcio, but he probably etched this cartouche after his own design, not after any of the high-relief stucco frames made for the palace's famous wall paintings.

94. In 1539, only two years after Sebastiano Serlio had published *General Rules of Architecture . . . According to Vitruvius, Book Four* in Italian in Venice, Pieter Coecke van Aelst translated it into Flemish, illustrated it, and published it in Antwerp without Serlio's permission. Three years later Coecke published his French translation of the same book, issuing a second edition in 1545. Since Serlio himself had neglected to put his name on the title page, Coecke's translation does not mention Serlio (nor does it mention Coecke). It is entertaining to find this extraordinary example of the Netherlands grotesque on the 1545 title page of a book explaining classical architecture according to Vitruvius, who detested the grotesque.

94

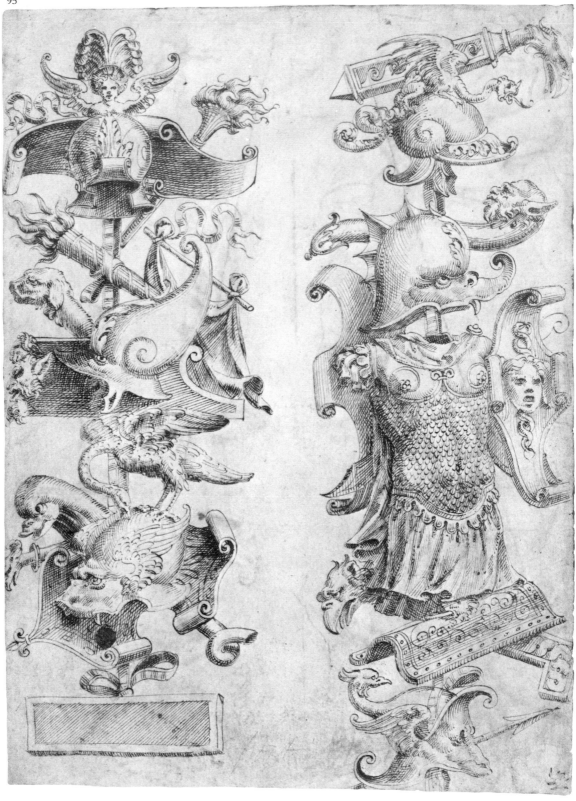

95. The antique display of the booty of war—the arms of the conquered hung on a wall or on a pole for a triumphal parade—became a Renaissance decorative motif of great popularity. In this sixteenth-century example, the fantastic crested helmets, the burning torches, and the curling convex shields (which curve in the wrong direction to deflect sword blows and must therefore be only cartouches, not accoutrements of war) all suggest that the drawing is a pastiche, a decorator's imagining. It is attributed to Enea Vico because it contains elements found in an engraved set of trophies (1553) also attributed to though not signed by him. Surely Vico, an antiquarian and collector, was more familiar with antique armor than the unknown draughtsman of these trophies seems to have been.

96. In 1550 Cornelis Bos engraved a triangular design that would fit into half of a pediment, perhaps on a soldier's monument. Later he added a helmeted head to the heap of antique-style arms and armor. Trophies of arms, whether antique or Renaissance, do not contain unattached parts of warriors. The appearance of the head suspended in mid-air, the ill-considered construction of the rigid chin strap (which requires the face mask to be worn on the top of the head), and the locks of hair and beard superimposed on the spear handle and scabbard tip prove that the head is a later and unsuccessful addition. The sphinx in front of the fan-shaped plume occurs on other fantastic Renaissance helmets, including the drawing once attributed to Enea Vico (95).

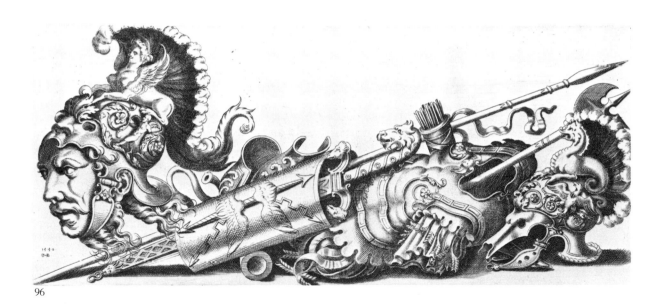

96

97, 98. This set of six panels with scenes from the lives of the gods — Mercury and Argus, Flora, Vulcan and Cupid (97); Mars and Venus, Venus and Cupid, Apollo and Marsyas (98) — is not signed by either the engraver or the designer. The publisher has added his name, *Ioan. de Wael,* to one plate and is probably the obscure Antwerp painter Jan de Wael (1588–1633), not known as a print publisher. For over a century these trophies were thought to be engraved by René

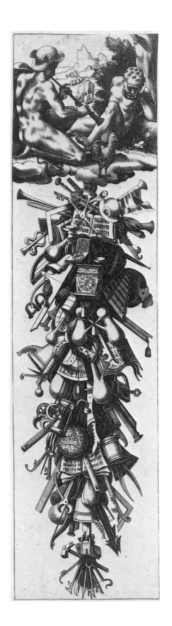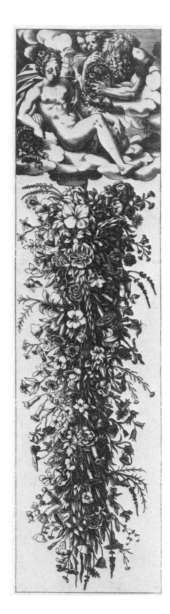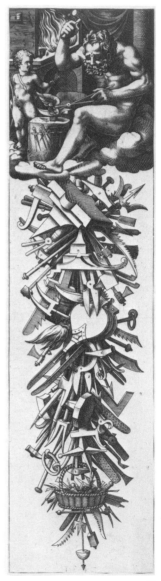

97

Boyvin after designs by Rosso, but scholars are now unsure of the engraver's identity and think the designs were the work of Léonard Thiry. Identification snarls like this are common in connection with sixteenth-century ornament prints because engravers borrowed, adapted, combined, and redesigned motifs from each other's work. They often neglected to sign their own prints and as heads of shops frequently put their names on work produced by everyone in the shop.

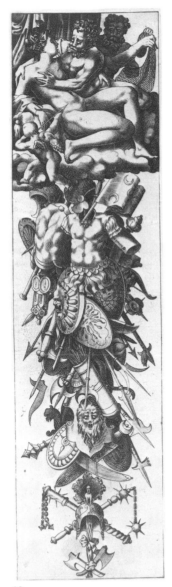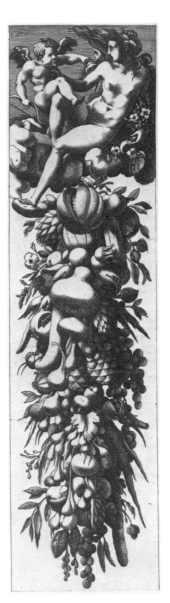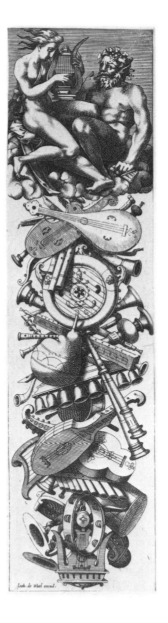

98

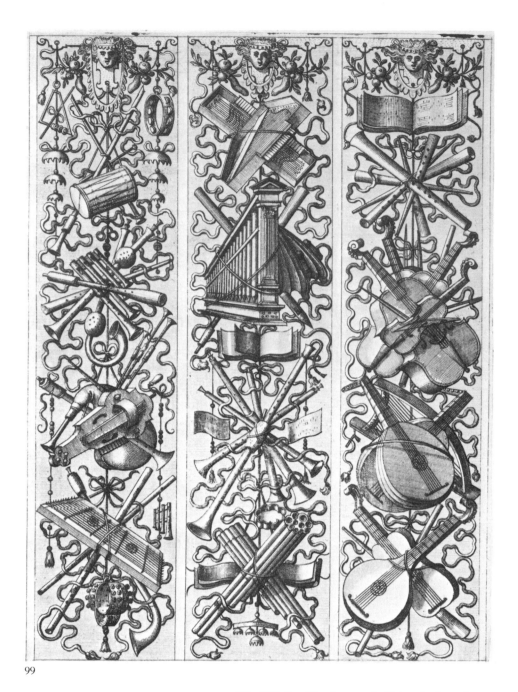

99

99, 100. Jan Vredeman de Vries designed a set of trophies that was published by Gerard de Jode in 1572, probably in Antwerp. Mainly trophies of arms, the set also included this page of musical instruments (99) and another of agricultural implements (100). In each case the objects are shown strung together with ribbons or a tasseled cord. The center band of

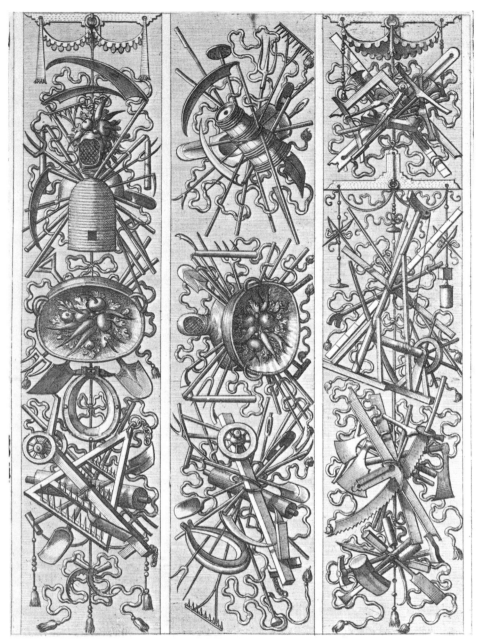

100

agricultural implements is meant to be used horizontally. Some of the military trophies are for curved spaces; perhaps they are for painting on majolica plates and platters. The way in which these designs completely fill their vertical spaces contrasts with the elegance of the less cluttered "Boyvin" trophies (97, 98).

101 102

101, 102. Not usually considered a motif to-
day, the human head frequently appeared as
ornament in the first half of the sixteenth cen-
tury. Most often found in circular moldings,
human heads (as distinct from masks) and
sometimes entire busts decorated furniture
and the exterior walls and interior paneling of
French châteaus. Occasionally heads were
portraits of the owner (the Museum has a cel-
ebrated example of the head of Cardinal
d'Amboise in a panel from his château,
Gaillon, about 1510–15), but more often
they were idealized impressions of notewor-
thy people from the past—Greek heroes,
Roman soldiers and emperors, King David,
or Charlemagne, for example.

The most common explanation of the use
of heads for decoration is that designers were
inspired by Roman coins. Coins were illus-
trated in books on Roman antiquity (103),
and the profiles on them were usually por-
traits of emperors. Hence the antiquarian,
numismatist, and ornament printmaker Enea
Vico used coin portraits to illustrate two
books—*Portraits of Roman Emperors* and *Por-
traits of Roman Empresses*. Vico reproduced
each coin (including its inscription) and en-
shrined it in an ornamental surround—on an
altar, a pedestal, or a monument—in imita-
tion of the antique style. His Cornelia (101)
is more successfully antique than his Antonia
(102), which with its anticlassical assemblage
of antique motifs obviously dates from the
1550s in Italy, not from Roman antiquity.

103. Engravings of Roman coins cut (be-
fore 1917, when they were acquired by the
Museum) from an unidentified sixteenth-
century book on antiquity.

104

104. Charles V, born in 1500, became Holy Roman Emperor when his grandfather Maximilian died in 1519. In 1520 Charles made his first trip to Germany, to convene the Diet of Worms. Daniel Hopfer etched this portrait of Charles as a young man, giving him only his title of "Catholic King [of Spain]" without "Holy Roman Emperor." On the single escutcheon Hopfer put his own initials, DH, instead of Charles's coat of arms. Hopfer silhouetted and softened the famous profile, flattering Charles by showing him in the manner of a Roman emperor on an antique coin. But Hopfer was German, an etcher, and a decorator of armor, and he could not refrain from adding utterly delightful monsters, birds, leaves, and flourishes.

105. Lyons was a thriving book center, pro-ducing hundreds of books with title pages decorated with caryatids, strapwork, and cartouches. It was a major stop on the main route for northern artists on their way to Italy to study and for Italian designers and artisans traveling to work at Fountainebleau. From a Lyonese family of goldsmiths, engravers, and carvers, Pierre Woeriot (1532–after 1596) knew the latest fashion in strapwork grotesque. The Netherlands idea of confining a body in strapwork is to be seen on the grip and the guard of the sword hilt at the left. The artist's initials, PW, appear between the hands of the faun on the hand grip. Masks of all kinds are everywhere, full face and in silhouette, human (male and female) as well as animal. The dagger hilt and scabbard at the right contain jewels, which implies that the armor in question is not for combat.

105

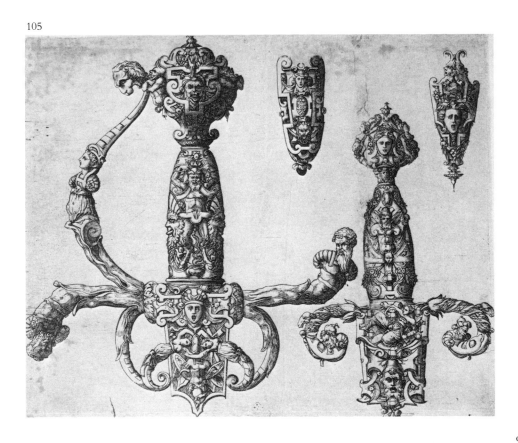

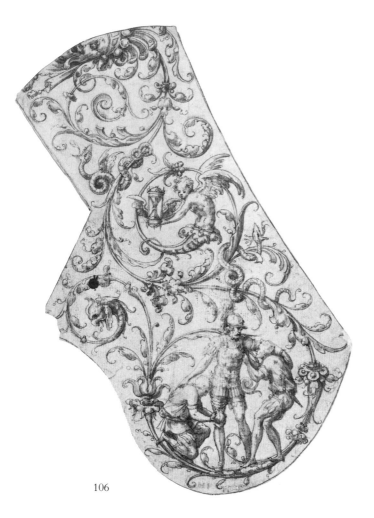

106

106. Originating from the half-mask at the top of this shoulder defense and curling majestically in three scrolls graduated in size around an emblem of the swift passage of time, a pseudo-acanthus rinceau with two serpents coiled in its branches enframes a noble warrior being helped into his harness by two servants. This beautifully drawn piece of parade armor with a completely decorated surface was designed by a man who was either a goldsmith himself or who customarily furnished patterns for jewelry or precious metals. It has been attributed to Etienne Delaune.

107. A handsome dagger with a handle composed of howling dogs' heads has a grip decorated with two pairs of monsters. Underneath its guard (a lion mask with ram's horns), a knife and fork are concealed. Below a band with a rinceau of fig leaves held by children and a laurel-wreathed head in profile is a murder scene. The protagonists, approximately the same age, are probably Cain and Abel. Their marvelously foreshortened bodies have been fitted into a narrow vertical space with consummate care. Aldegrever's monogram is beneath the date, 1539. Below is another band of leaves, more children, and additional heads in profile. A symmetrical grotesque with a satyr couple leads the eye downward to the large satyr mask and finial. Emblem readers may be able to invent an explanation for the dog, lion, and satyr masks, paired monsters and satyrs, used in connection with the story of Cain and Abel.

108, 109. Unidentified are four late-sixteenth-century designs for pole arms—tasseled, beribboned, and fantastic—probably destined to be used in a theatrical spectacle of the kind designed by Bernardo Buontalenti for the Medici.

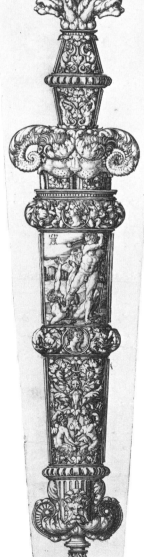

107

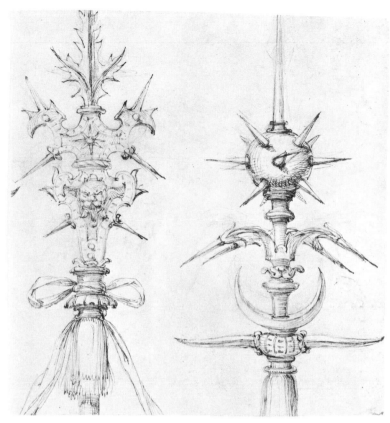

108

109

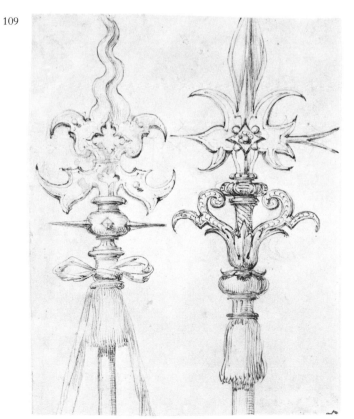

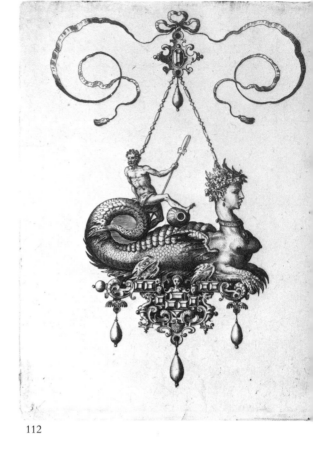

110

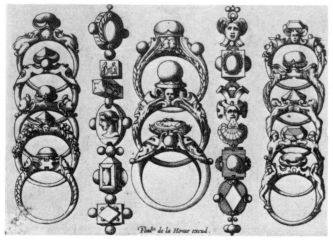

111

112

110. Pierre Woeriot found it profitable to design rings; his book of nothing but ring designs was published in Lyons in 1561 and contained a variety composed of contorted human bodies, serpents, rams' heads, and terms. It also included a ring in which a watch was set and one memento mori made of skeletons and a skull.

111. René Boyvin's rings, containing pearls and cut gems, are engraved on a plate with two bands of individually designed links. Once a client had chosen a link, a goldsmith would make a chain or bracelet. The twenty engravings in Boyvin's booklet are unsigned

and undated, bearing only the name of the publisher, Paul de la Houue, who worked around 1600 and must have acquired the metal plates after Boyvin's death in 1598.

112. Hans Collaert's set of large, jeweled-pendant sea monsters is dated 1582. Resting on a symmetrical base studded with table-cut gems and hung with pearls, a female sea monster related to a sphinx majestically carries a mariner on her back. As a finished jewel her scaly body would have been enameled blue-green, contrasting with her pale enameled flesh and the colored gems.

94

113, 114. There are many sixteenth-century designs for pendant jewels; they almost invariably approximate the size of the pendant to be made—about two to three inches by two to four inches. Very often these small prints have come adrift from the booklets and sets in which they were issued. Sometimes not signed (unlike the two illustrated, on which Virgil Solis's initials are prominent), they have frequently been wrongly attributed because they were mounted in scrapbooks of jewelry designs by other artists.

The little prancing horse-leaf has on his head the mouthpiece of a whistle, but any jeweler trying to make this whistle would be obliged to do some redesigning before it would make any sound. The moresque designs on two pendants shown from the back were to be enameled in color.

115. Toward the end of the century grotesque designs, plain or with enameled backgrounds, were used by Theodor de Bry for two buckles, a clasp, and a heart-shaped element.

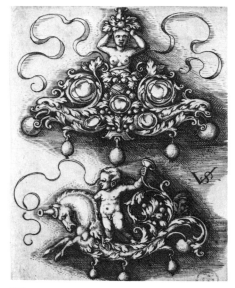

113

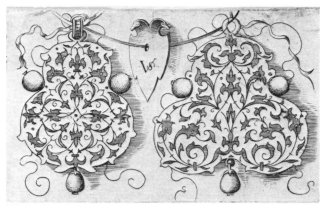

114

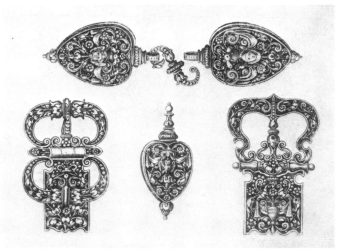

115

95

116

center of the engraving is decorated with the head of a Roman emperor and was a status symbol in the sixteenth century.

118. Once the forty-eighth leaf in a design book attributed by John Hayward to Erasmus Hornick, this drawing shows personal utensils of the kind any gentleman required: knives, fork, spoon, scissors, earspoon, and nail knife. The Museum's fourteen other drawings from the same design book show platters, cups, flasks, buckets, sword hilts, an egg server, and two braziers. Although, as Hayward says, these drawings may have belonged to Rudolf II, the objects they represent are not of a quality high enough for an emperor of the Holy Roman Empire. Not as elaborate as Hornick's prints and other drawings, ours may have been drawn by someone working for him.

119. This print is signed *Stephanus F[ecit]. Cum pri[vilegio] Regis* ("Etienne made it, with the king's privilege"). There is no doubt that Etienne Delaune made the print, but concerning the design there is a question. In the Berlin Kunstbibliothek there is a drawing by an unknown Master Guido of a jeweled medallion used as a title page. Obviously in a fit of pique, Master Guido wrote in the center, "Here follow the designs of Mr. Guido and Jean Cousin, designers of almost all of the work of Etienne [Delaune] except a large group by his son and some few others, L[uca] Penni and so forth." At present there is no way to tell whether Master Guido's allegations are correct.

Our mirror is dated 1561, just below the cauldron and above the mask. The central oval tells a story of rejuvenation. Medea, in order to please Jason after he returned with the Golden Fleece, rode off in a chariot drawn by serpents to procure magic ingredients. These she boiled in a cauldron. Draining Aeson, Jason's elderly father, of blood, she restored his youth by putting him in the

116. A gold or silver thimble was an appropriate present for a fiancée or a young bride. Jan Theodor de Bry has decorated thimbles with copies of recognizable paintings. The subjects concern love, or the Virgin, or virtues like faith, hope, and charity, and the round tops have emblems and mottoes.

117. The hinges in the handles of Aldegrever's two spoons of 1539 indicate that they were made for traveling and hunting. The combination dog whistle, knife, and spoon in the

96

117

118

119

magic brew. This involved story is embed-
ded in an equally involved frame studded
with precious stones and pearls. The loop at
the end of the handle shows that the mirror
could be hung by a ribbon or a chain from
the wrist or belt.

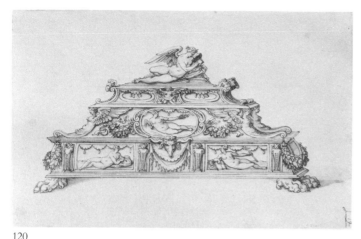

120

121

120. Twenty-four designs for goldsmiths attributed to the shop of Francesco Salviati stayed together until after 1956 when their protective vellum binding was removed and the drawings were sold separately. Leaf 19, one of several in the Museum, is a design for a precious rectangular container, but since the designer (who must have been an artist, not a craftsman) gave no practical information — no keyhole, no handles, no visible joint for the removal of the top — the use of the object is not clear. Four naked reclining ladies may be emblematic; the one on top (a muse?) is winged and writing, another (a personification of religion?) has a book and a cross, a third has a wreath and a handful of what appear to be reeds, and the fourth does not seem to have any attributes. Rams' heads, garlands, and half-scroll-people are simply decorative motifs without significance. The ambiguity of the object is possibly intentional; by changing the attributes of the ladies, the casket could be adapted to the requirements of various clients.

121. Mathias Zündt has designed a gold or silver-gilt candlestick not meant to be carried. The elaborate and detailed decoration, which completely covers the surface, indicates that the basic technical problems of goldsmithing had already been solved. It is unusual for a goldsmith to include a guttering candle and its light in a design.

122. Antonio Fantuzzi's cup, etched about 1543, is supported by a satyr family. On the cover Bacchus, Ariadne, and Cupid recline among grapevines, in front of a bald-headed child holding a ring. Two similar rings hang from lion masks on the bowl but are so small and so awkwardly placed that as handles they are useless. Unlike covers on many sixteenth-century standing cups, this one with bunches

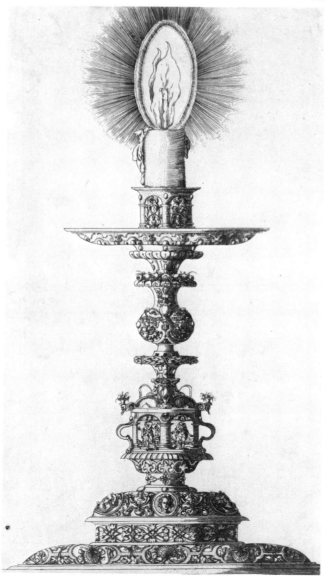

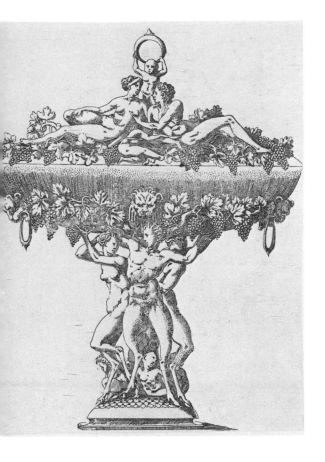

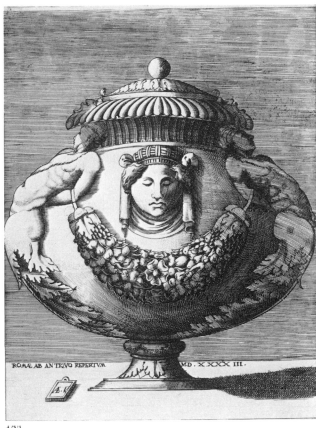

123

of grapes at the edge was probably not for drinking. Also, it could not be easily grasped, and if filled could not be set down until empty again.

123. In 1530–31 a set of twelve vases, each inscribed *sic • Romae • antiqvi • scvlptores • ex • aere • et • marmore • faciebant* ("Made at Rome after antique bronze and marble sculptures"), was engraved by Veneziano. Some ten years later another set of vases after the antique was engraved by Vico, who inscribed his set *Romae ab antiqvo repertvm* ("At Rome, obtained from the antique") along with the date, 1543, and his initials, AE.V., as can be seen in our illustration. Here Vico has used AE., the abbreviation for the Latin form of his first name, *Aeneas,* but in number 15 he has used E., for the Italian form, *Enea.* These two sets of vases, offering images of archaeological in-terest, were immediately copied in Italy, France, and Germany, usually with no men-tion of the antique, Vico, or Veneziano. Al-though neither Vico nor Veneziano said where in Rome he had seen the vases and urns he engraved, it is quite probable that both saw them in antique sculpture gardens displaying the collections of the popes and of Cardinals Carpi, Caraffa, Cesi, Ippolito d'Este, and Farnese. These private collections were open to antiquarians, collectors, artists, and schol-ars; consequently the same vases were seen, drawn, and engraved by more than one artist. Often the antiquities had been damaged and were "restored" by printmakers, who drew in handles, lids, spouts, or finials, as needed. One urn was "restored" by several different printmakers, who used lion-headed, griffin-headed, or dog-headed handles; the vase is almost unrecognizable.

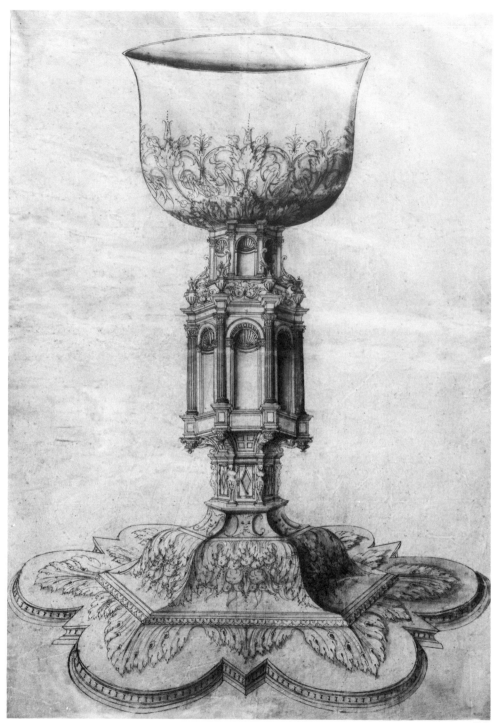

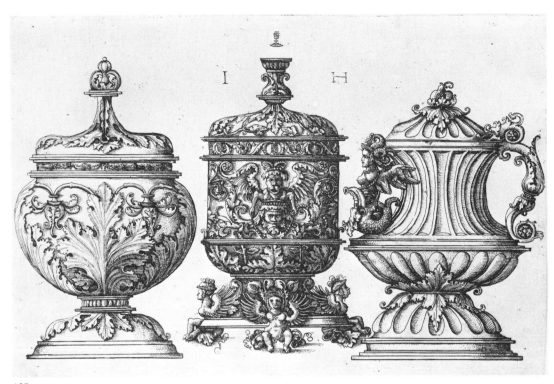

125

124. A drawing on vellum is so out of scale that it cannot have been drawn by a designer, who would, by the mid-sixteenth century, have used paper, not vellum. A shop draughtsman selected various stock motifs from Jacques Androuet Du Cerceau's vocabulary and starting with the base stacked them one at a time. Preoccupied with a meticulous finish, he found too late that his perspective was incorrect and that there was not enough room for the bowl of the chalice.

Du Cerceau, with several sons and a shopful of assistants, produced all sorts of ornament prints, but apparently he wanted to be an architect.

125. Jerome Hopfer, Augsburg etcher, made a practice of copying the prints of others. Here he has taken three of Albrecht Altdorfer's covered cups (1520–25) and put them on a single plate. The three harpies and half of a winged bull en face on the central cup show that Altdorfer, if not Hopfer, knew the ornament prints made in Italy by Nicoletto da Modena, who worked from 1500 to 1512 and who used this distinctive motif at least three times.

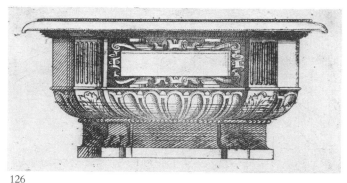

126

126. Differing in size and shape from the rest of Du Cerceau's patterns for goldsmiths, this unscaled object may be a font, a sarcophagus, or the basin of a fountain—that is, a large stone container rather than a silver saltcellar or a lead cistern. Du Cerceau, in this undated etching, uses the architectural draughtsman's trick of showing an overhang on the lip as though it were for rain drips on the cornice of a building.

127

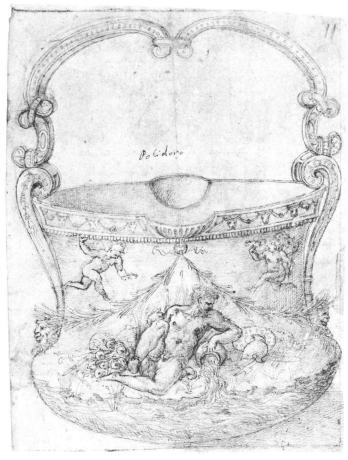

127. Four drawings for buckets attributed to Girolamo Genga (1476?–1557) are decorated with pagan subjects; therefore it is unlikely that they are holy water containers. The artist has designed with a fine disregard for the artisan charged with making the object. Whether this bucket is to be made of bronze, of engraved crystal with metal mounts, or of majolica, two parts of the design will not work: the garland and the segmented but rigid handle. *Polidoro* (that is, Polidoro Caldara da Caravaggio) was later—and mistakenly—added.

128. In 1594 Paul Flindt of Nürnberg published a pattern book for professional goldsmiths. His forty plates illustrate cups, beakers, goblets, a ewer, a pricket candlestick, a hanging lamp, and goldsmiths' flowers. Some of the objects were practical, but many others, too awkward to drink from, to pour from, or even to pick up, were meant to be shown on sideboards. Flindt offered several designs for columbine cups, a favorite Nürnberg type and a test piece for goldsmiths wishing to become masters in the guild. By the time these prints were published, Nürnberg goldsmiths no longer were required to make their own designs for the test pieces and could, therefore, use Flindt's.

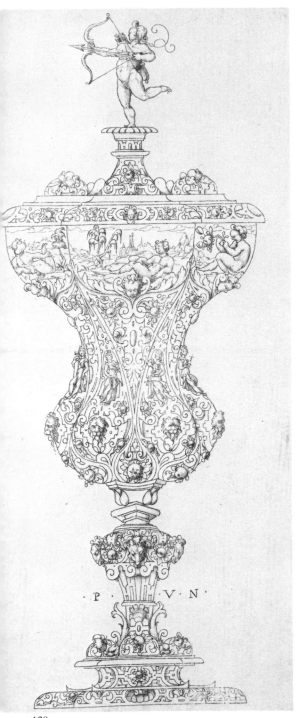

128

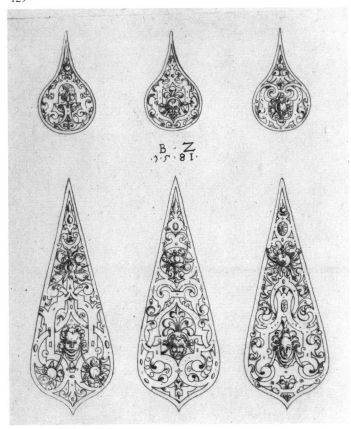

129

129. Teardrop-shaped elements of different sizes were designed and engraved in 1581 by Bernhard Zan of Nürnberg as components for columbine cups. Flattened strapwork with masks and bouquets of fruit and vegetables completely covers the cups, the surfaces of which curve in more than four directions (128). Another sheet of Zan's patterns, also made strictly for professional craftsmen, includes curved bands for bases and goblet stems.

130

130. A master of the dotted print (so-called because the lines are merely a series of dots made by a punch—the technique is an adaptation of a goldsmith's preparation for embossing metal), Jonas Silber, working in Nürnberg from 1572 to 1589, used figures from antiquity and landscapes with ruins in his round designs for the insides of shallow standing cups. *Bacchus Seated on a Barrel*, signed IS and dated 1582, has for a background a landscape reminiscent of those composed fifty years earlier in France by Jean Cousin and the school of Fontainebleau.

131. A dotted print from Johann Sibmacher's book of goldsmiths' patterns *(Fysirvngen zum Verzeichnen fvr die Goldtschmidt,* Nürnberg, 1599) shows the main part of a cup with the screws that secure it to its foot and finial. Those of us who are used to seeing only completely assembled cups in museum vitrines may not realize that the cups come apart; they were made in sections and were fastened together. Anyone interested in fakes, restorations, and later assemblages would do well to consider whether the parts of a vase match and are harmonious, for missing and damaged sections have sometimes been replaced. To see how this element was mounted, see

the cup by Sibmacher's contemporary, Jonas Silber (132).

132. Another dotted print by Jonas Silber shows a completely assembled pear-shaped cup with a stem composed of a twisted tree trunk and a bear treed by a dog. The allover strapwork decoration has occasional accents—a mask and fruit bouquets—in high relief.

133. The extension to the middle class of the market for gold and silver objects led Virgil Solis to design a series of cups that could be disassembled and used for more than one purpose. Unlike the luxurious gold and silver extravaganzas (128, 132, 134, 135) meant only to be displayed, Solis's cups *(Schale)* could, as his labels tell us, become candlesticks *(Leuchter),* salts *(Salcz f[ass]),* dishes *(Geschir),* wine tasters *(Schmek),* and little clocks *(Urlein).* His twenty-four etchings of multipurpose cups were probably done in the 1550s.

131

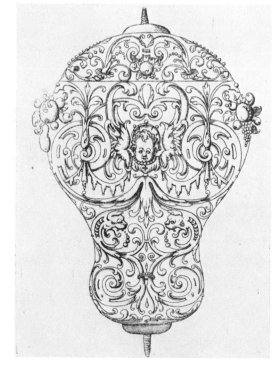

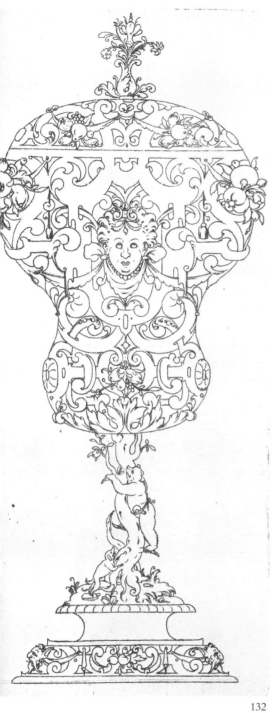

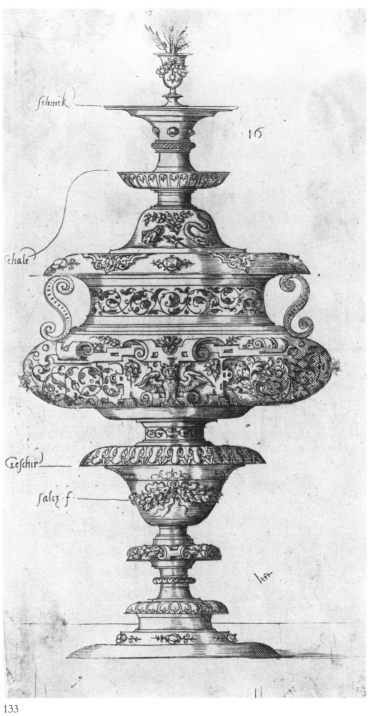

schmck

16

schale

Geschir

salcz f

132 133

105

134. Flindt's cup (signed P[aulus] V[lindt] N[ürnberg]), designed to be carried out in gold or silver in the form of a shell, is a late-sixteenth-century survival of a medieval fashion. Especially in Germany, unusual natural objects from distant lands—ostrich eggs, coconuts, and nautilus shells—were mounted with gold and silver as treasured display cups.

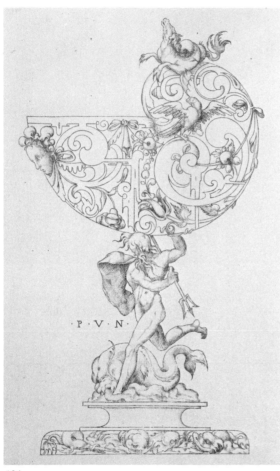

134

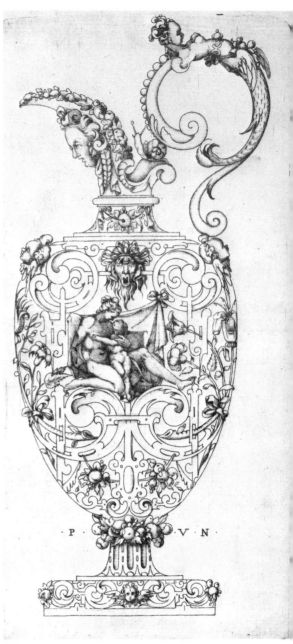

135

135. Another kind of display vessel was the ewer, although ewers with matching basins were also made to be used—they were offered by table servants for hand washing. With the exception of the bandwork and the central vignette, the motifs on Flindt's showpiece— masks, fruit and flowers, an extralarge mask under the lip, and a handle composed of a

leaf-tailed woman bending backward—were used repeatedly for forty or fifty years and are derived from antique bronzes like those engraved by Vico (123) and Veneziano.

136. One of a set of cups and vases for display was made about 1551. Over the years scholars have disagreed about the identity of the

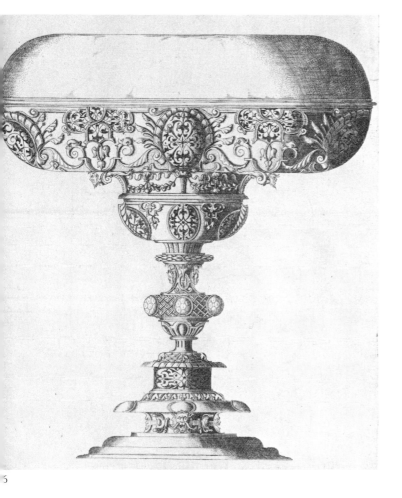

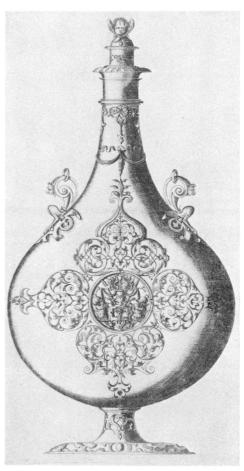

designer, who has variously been called the
Master of the Craterography, the Master of
1551, Wenzel Jamnitzer, or Mathias Zündt.
One of the characteristics of this group of
cups and vases is the combination of a com-
plicated silhouette, fairly simple relief pat-
terns, and flat moresques intended to be
engraved and enameled.

137. By the same designer as the display cup
(136), a footed bottle with rings for a cord or
chain is meant for traveling. It has a compar-
atively restrained ornamental program—a
coat of arms surrounded by a moresque
flourish—to be engraved.

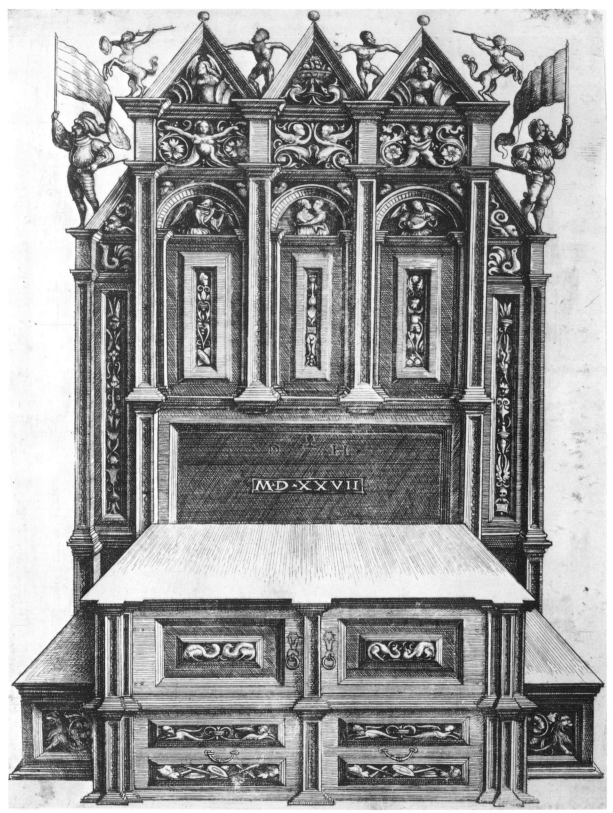

138

138. A single design for a bed was produced in 1527 by Daniel Hopfer, an etcher of armor. His undated etching of three washbasins (139) was probably done about the same time. He also designed church furniture, usually in an ambiguous fashion. Ambiguity was the intentional result of Hopfer's shrewd attempt to make his designs salable to various kinds of craftsmen. His bed has been mistaken for both a religious storage cupboard and a marriage chest, but if the emblems of lust—wild men, centaurs, monsters, and lovers—are read, one can only conclude that this is a bed. With drawers and cupboards underneath, it is very similar to the Museum's fifteenth-century bed from Florence.

139. Washbasins with cisterns and towel racks were important parts of sixteenth-century middle-class households. Designs for them, to be carried out in carved and inlaid wood fitted with brass, appeared from the 1530s into the seventeenth century. Becoming more and more elaborate, especially in Switzerland and Germany, the basins and cisterns were incorporated into walls entirely composed of wooden paneling and storage units. Illustrated here are three modest designs by Daniel Hopfer.

140. One of the pieces of furniture that was especially useful in homes with no closets was a chest in which to store textiles. A sixteenth-century Italian cabinetmaker who catered to the middle-class demand for practical, beautiful, well-priced objects drew some simple designs from which his customers could choose. Like many other competent artisans, this one had trouble drawing and made a few false starts, relying on corrections with a pen and dark ink. To support the chest he used sturdy lion's-paw feet, turning them into acanthus leaves to hide the transitions at the corners, just as Verrocchio did on the Medici sarcophagus (164).

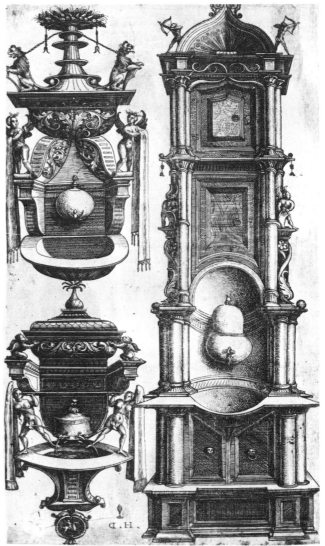

139

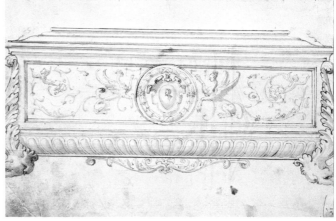

140

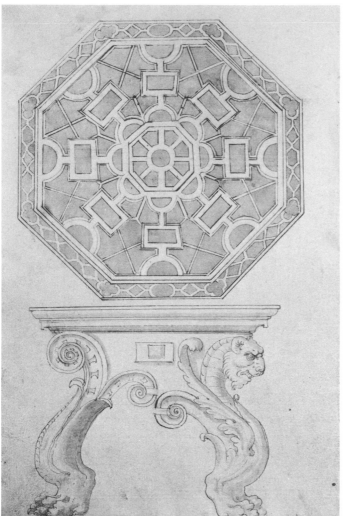

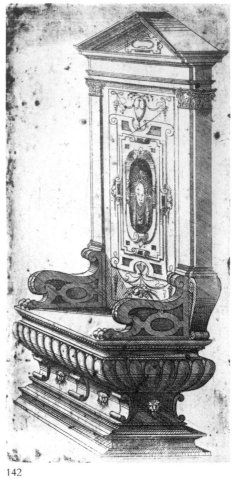

142

141

141. Another leaf (numbered 35) from the same design book that contained the drawing for a chest (140) shows an octagonal table with excessively heavy legs, one of which extends beyond the edge of the tabletop. If that was intentional, and not simply the result of clumsy draughtsmanship, the proportions may indicate that the table was to be made of stone rather than wood.

142–144. At mid-century a whole book of furniture designs—some forty-five plates—was produced by Du Cerceau without a title page, introduction, or text. The furniture shown (beds, tables, one chair, twenty buffets and armoires) is so elaborate that no ordinary cabinetmaker would have attempted to make it. The buffets are especially ornate, displaying caryatids, sphinxes, masks, garlands of fruit or flowers, trophies, vases, and other favorite motifs. Perhaps the simplest design is the one for a chair. More like a throne, it has a high back with carving in low relief, and it may have had a small, concealed storage space. Although many pieces are shown built on platforms to raise them off cold stone and tile floors, comfort appears to have been a minor consideration. The beds

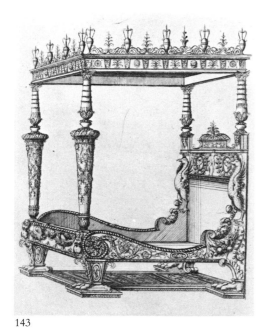

143

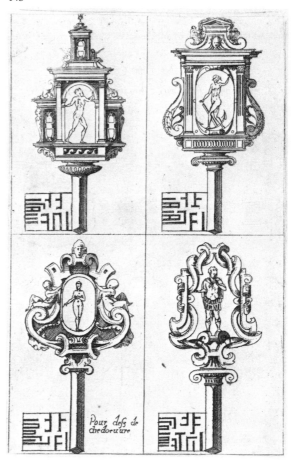

144

145

are shallow wooden boxes with all sorts of decorative protuberances—lion masks, swans, snakes, and monsters—on which to bruise the human body. Although the French word for this kind of furniture is *meubles* (literally, "movables"), there is little in Du Cerceau's book that could be easily moved, and every piece requires the large amounts of space found only in palaces and châteaus.

145. Among the metalwork designs by Du Cerceau are hanging shop signs and furniture hardware—bolts, escutcheons, drawer pulls, handles, and keys. Of his five etched plates of keys, four are simply labeled *Pour clefz* ("For keys"), but the fifth (illustrated here) is inscribed *Pour clefz de chedoeuure* ("For masterpiece keys"), meaning that these intricate examples were patterns for test pieces to be made by apprentices seeking admission to the locksmiths' guild. The central human figures are based on the many versions of Jacopo Caraglio's engravings of gods in niches, a series of twenty prints made after Rosso in 1526 and adapted more than once by Du Cerceau for ornamental purposes.

146

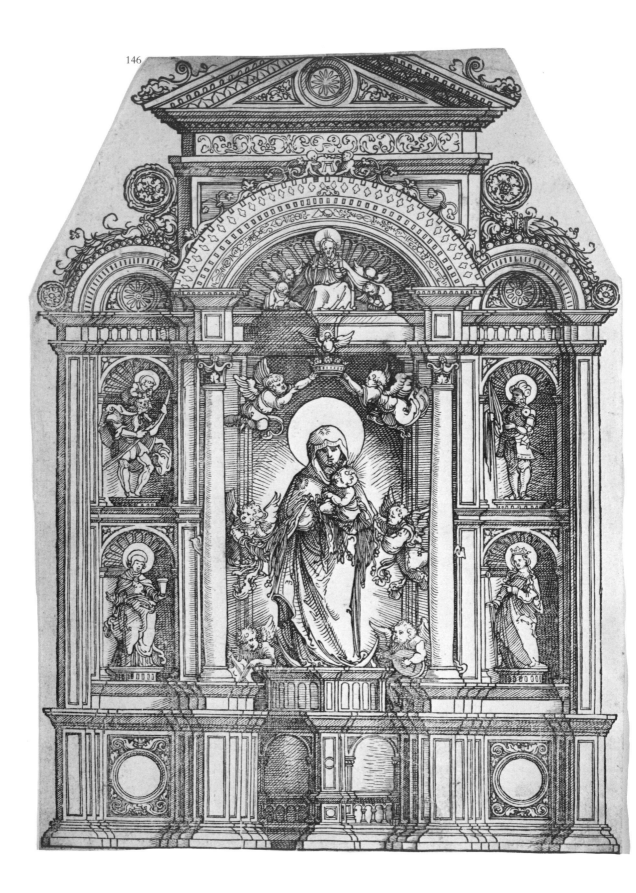

146. Albrecht Altdorfer—painter, architect, and engraver—not only designed and etched an often-copied set of cups for goldsmiths, but about 1520 he also made a woodcut design for an altar. For the new stone pilgrimage church at Regensburg (built on the site of the synagogue demolished after the Jews were expelled from the city on February 21, 1519), the frame is truncated in order to fit into the space where it was to be set. The Virgin stands on the crescent moon, symbol of chastity, and wears the fringed mantle with stars (on the head and the shoulder) characteristic of Regensburg's miraculous wooden statue, *Die Schöne Maria,* or "The Beautiful Virgin." A designer with a painter's eye, Altdorfer was not concerned with the practicalities of suspending the four baby angels crowning the Virgin and holding her robe. Successful as architecture, the frame provided niches for Saints Christopher, Barbara, George, and Catherine.

147. This woodcut is thirty-seven inches high, cut on two blocks, and printed on two sheets of paper that were pasted together after they were printed. Its giant size is extraordinary since a stonecarver or goldsmith could carry out a given design on any scale he wished. Only the perspective indicates that the whole edifice towers over the observer, who must look up at more than half of it. Michael Ostendorfer, who dated the peculiarly drawn pedestal 1521, was working in Regensburg, probably for the new Church of the Beautiful Virgin, and he must have had in mind not a piece of silver altar furniture but a stone tabernacle possibly twenty-five feet high, judging from eye level at approximately five feet. The tabernacle for storing the reserved host (in the lowest section, guarded by angels) appropriately contains a theological parallel—the Fall of Manna from the Old Testament and the Last Supper from the New Testament.

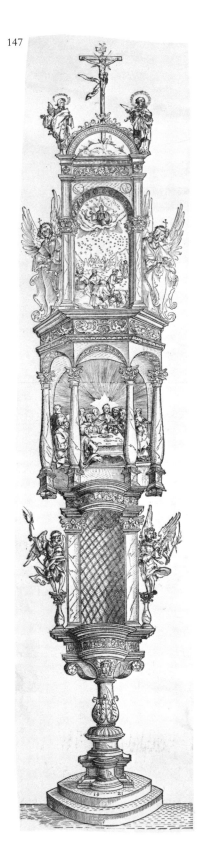

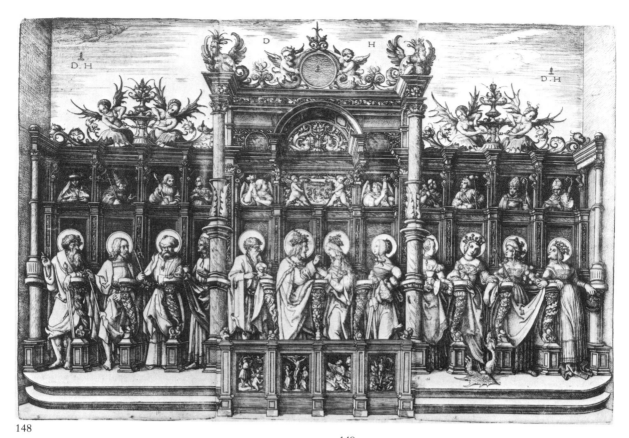

148

149

150

114

148. When printed and pasted together, three separately etched plates signed by Daniel Hopfer form a singularly undefinable object of a mostly religious nature. An elaborately carved framework is fitted into a wall niche, which unaccountably has several clouds. In a central tabernacle, underneath the sacred IHS monogram held by baby angels, Christ blesses the Virgin, who wears the crown of the Queen of Heaven. A complement of male and female saints standing or leaning in choir stalls is identified by individual attributes. A second group of saints, in reduced size and half-length, could only be carried out in relief sculpture or paint since there is no architectural space for these observers to occupy. Because sirens or harpies and several varieties of monsters decorate the top of this curious object, it must predate the Council of Trent (1545–63), which banned pagan decorations from the Christian church.

149, 150. A Frenchman, trained in architectural draughtsmanship and traveling in Italy in the 1560s, saw this cabinet either in a palace or a church sacristy. He made a record of its unusual feature, the drop front (shown dropped open in the partial side elevation at left and immediately above in the front elevation), to take home to France. There the two sheets were bound into a scrapbook with other drawings of objects he had seen in Rome. On the verso of the front elevation is a plan of the Sette Sale in the Baths of Titus.

151. From the end of the century comes a drawing for an organ case bearing the arms of Pope Sixtus V (1585–90). It provides a choice of column styles—plain or decorated— the implication being that plans are in a preliminary stage and no contract has been signed.

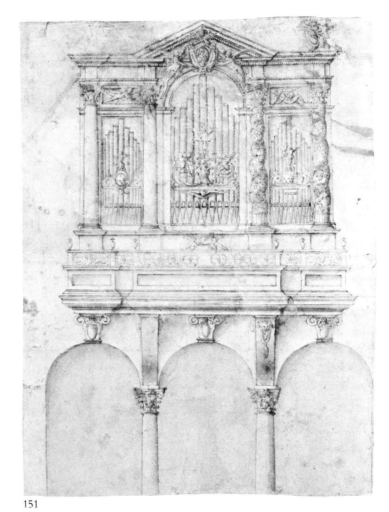

151

115

152

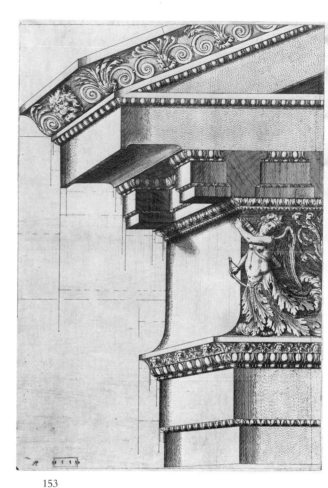

153

152, 153. Two unknown Italians, one in the late 1400s and one in 1555, recorded architectural sculpture in the Forum of Nerva in Rome. One must have been an architect; the other, who was not very adept at rendering architectural perspective, was skillful at ornamental details such as half-leaf-persons, acanthus leaves, lion and satyr masks, and egg and dart moldings tediously repeated. Both have left ruled construction lines, but there is little doubt that a builder or stonemason would be better able to use the precise measurements and accurate renderings of the earlier drawing. Because of the spelling of *Chornice* at the very top of the sheet (*Cornice* at the left is a later addition), it has been thought that the artist was Florentine or Sienese. If so, he had learned to use Roman

measurements—*palmi, oncie,* and *minuti*—instead of Florentine *braccia.*

154. A Composite column was labeled *Basa in Roma in el tenpio de Giove sotto capitolio* by the engraver, who was well advised not to sign his name to this ornate work, which is ugly both as an engraving and as architecture. The total accumulation of classical motifs—acanthus leaves, palmettes, rams' heads, masks, wreath, and moldings—produces a surprisingly anticlassical object. Could there really have been an antique column like this under the Capitol, or was some fragment "reconstructed" in the same fashion that Pirro Ligorio supplied missing parts and decorations in his renderings of antique sculpture?

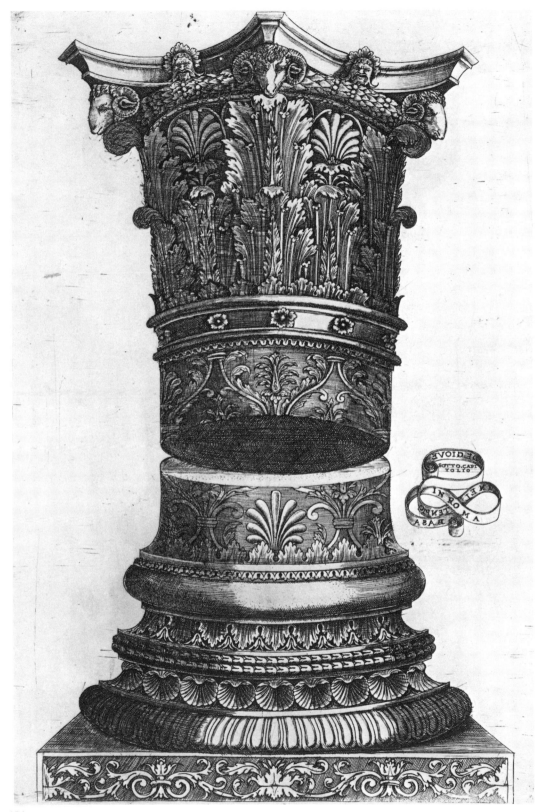

The banner/ribbon in the image reads:
DI GIOVE
SOTTO CAPI
TOLIO
NEL
IN ROMA
AMBRO
VASI

154

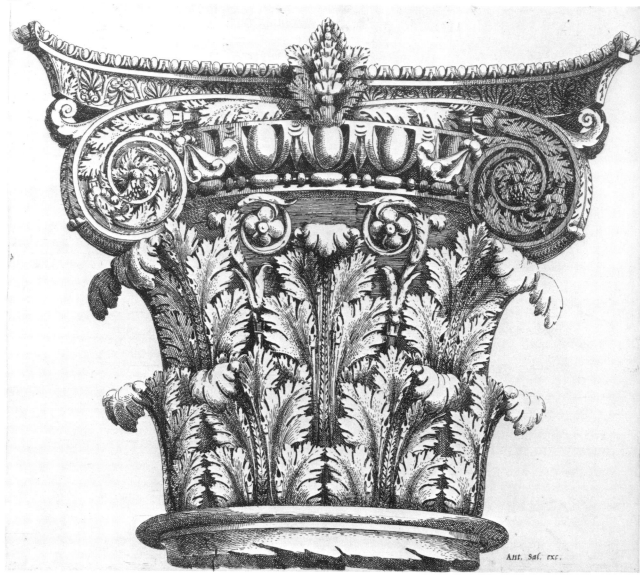

Ant. Sal. exc.

155. No one can yet be certain who the etcher Master L.D. was. He worked for the king of France at Fontainebleau in the 1540s, and like many of the artists there, he may have been Italian. This handsome Composite capital was issued in Rome before 1562, the year its publisher, Antonio Salamanca, died. An accurate architectural record of some Roman fragment, as a work of art it far surpasses the usual etchings and engravings of capitals, bases, and entablatures made by the topographical engravers in Rome. Henri Zerner has suggested (*The School of Fontainebleau,* New York, 1969, L.D. 69) that Master L.D., whose most beautiful prints are after Primaticcio, copied a Primaticcio drawing of a stone fragment, never losing the special quality added by the painter's eye.

156. The sixteenth century saw the rise and fall of a fashion of decorating palace facades with painted designs. A stone wall, smoothed out with plaster or stucco, was shallowly incised with the outlines of a decoration and then painted. This technique, called sgraffito, requires that every so often, depending upon the weather, the designs must be repainted. It is easy to understand that those few sixteenth-century painted facades still in existence have been repainted many times, and their original designs are now only ghosts. A facade drawing by an unknown Italian shows a stairway to a second-story doorway and is so detailed and elaborate that it has been described as a copy of an existing painted facade. Because there is little variation in the way the lines are laid—there is an overall, mechanical evenness—it looks very different from a project drawing. Deliberately cut by some former owner, only three strips stayed together long enough to be reassembled after they reached the Museum.

156

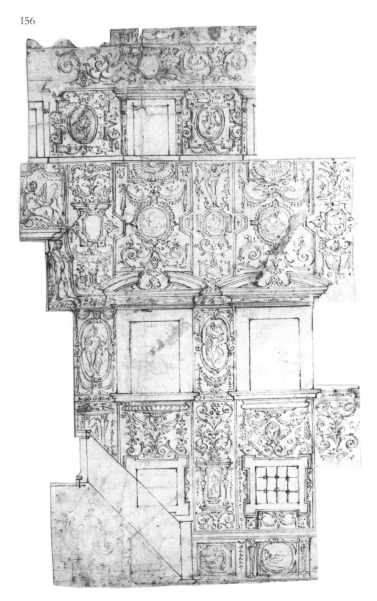

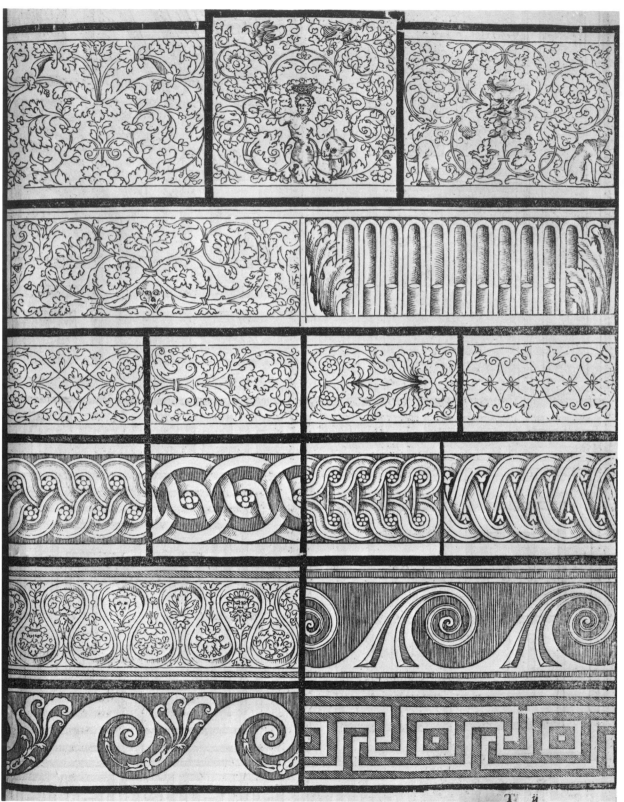

157. Although he had not yet published the first three parts of his monumental work on architecture, Sebastiano Serlio of Bologna had *Book Four* published in 1537 by Marcolini in Venice. Serlio sent a copy to Francis I of France, who thereupon invited him to Fontainebleau. Serlio's second volume to appear was *Book Three* (1540), devoted to a study of the antique and dedicated to Francis, who in 1541 appointed Serlio royal architect.

Near the end of *Book Four* is a section on the decoration of ceilings and interior woodwork. The page illustrated here shows a selection of friezes and running strip ornament of the most familiar and derivative kind— Greek key design, wave patterns, and four varieties of guilloches.

158. Daniel Hopfer probably found this rectangular pattern in Italy, where gilt palace ceilings were often so elaborately carved that they concealed the building's structure. Hopfer thought this pattern suitable for use in Germany, where wood was plentiful and paneled wooden ceilings offered upper-middle-class patrons the most for their money. A pattern like this is adaptable, and a woodcut copy of Hopfer's plate was published in an embroidery pattern book by Nicolo Zoppino in Venice in 1537, one year after Hopfer died.

158
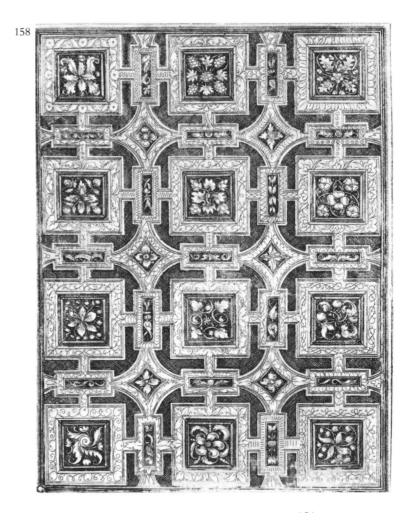

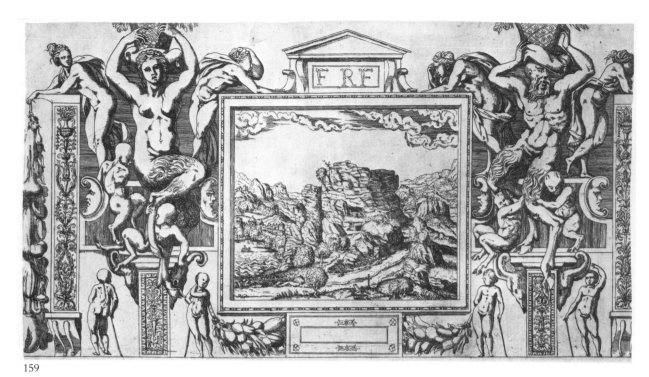

159

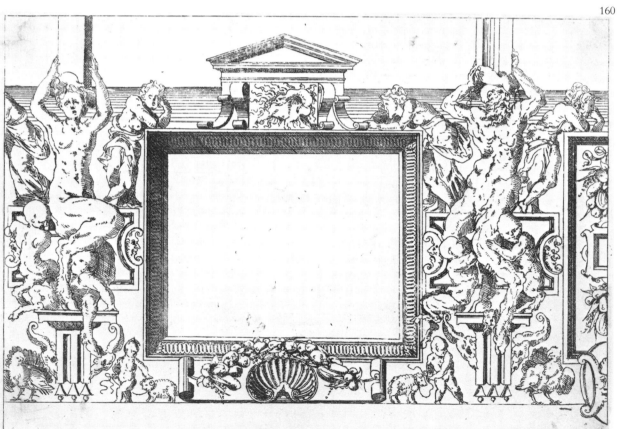

159, 160. In the 1540s some of the artists who had been working as *stuccatore* and painters in Fontainebleau under Rosso and Primaticcio made prints of the wall decorations in the Gallery of Francis I. One or two experimented with the etching technique, printing in a rosy red ink in imitation of red chalk drawings. They also experimented with the designs, omitting the central painted subjects entirely or replacing them with landscapes in the Flemish tradition. Antonio Fantuzzi etched his version (159) of the framework of *Ignorance Defeated* in 1543, substituting a rocky landscape for the figural subject. When the same framework was later etched by Du Cerceau (160) for his series of *Grands Cartouches*, he left the center blank, substituting a flaming salamander (emblem of Francis I) for the king's initials, and changed the incidental motifs at the bottom. As documents of what was carved and painted in the Gallery of Francis I, neither print can be believed.

161. Marine monsters appeared in ceiling decoration as far back as Roman times. This design has two signs of the zodiac in its rectangular center and mentions the four seasons without showing them. It stresses the construction of the ceiling and is evidently a section to be given to the man on the scaffolding doing the actual painting. The designer's instructions are written out with the verb "to make" in the imperative, and instead of color notes like those in the so-called *Spanish Grotesques* (65–67), color has been applied with a brush.

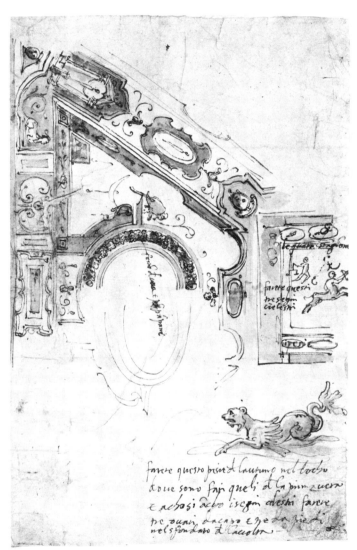

161

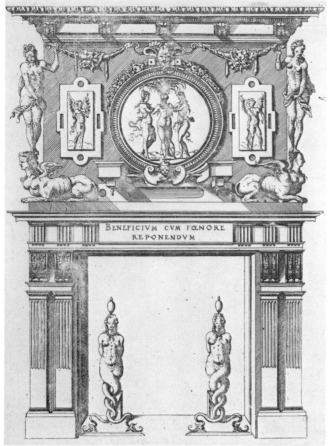

162

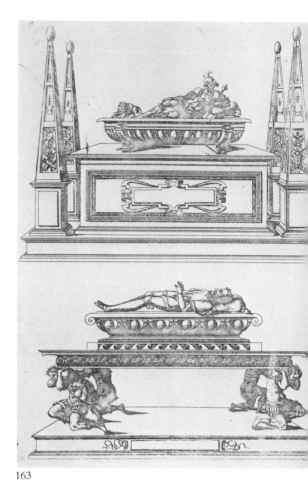

163

162. Jacques Androuet Du Cerceau, in the short introduction to his *Second Livre d'architectvre* (Paris, 1561), said that since he had recently published a book of plans and views of fifty different buildings along with architectural details and measurements, he was now going to offer a book of enrichments. With no explanatory text, he presented plates of fireplaces, the kind of palace attic windows called lucarnes, doorways, fountains, wells, garden pavilions, and tombs. There were more fireplaces than anything else, and he said that there were modest ones, sumptuous ones, and some in between. A particularly sumptuous one started with a handsome classical design, which was then encrusted with female figures—there are the

three Graces in the center medallion, two Venuses balancing on the heads of sphinxes, and two double-tailed mermaids. Du Cerceau seems to have been especially fond of mermaids with two twisted or braided tails, for they occur in his designs for caryatids, beds, court cupboards, chimneypieces, andirons, a royal wagon (31), and grotesques both large and small.

163. Another enrichment from Du Cerceau's *Second Livre d'architectvre* consists of two tombs for soldiers. The one above uses four obelisks, a motif especially popular in the sixteenth century; elsewhere in the same book Du Cerceau used obelisks for andirons and

124

for a fountain. He had seen real obelisks in Rome and woodcuts of them in Serlio's *Book Three* on antiquities (1540). He had also, in 1550, etched the many obelisks in *Fragmenta structurae veteris,* after Léonard Thiry. Early in the century interest in obelisks, particularly on the part of French and Flemish artists, was probably linked to a fascination with antiquities, but gradually obelisks assumed emblematic meanings. Here Du Cerceau has added compartments filled with trophies of arms.

The motif of warriors in Roman armor kneeling to support a fallen comrade who lies in effigy on a sarcophagus was not invented by Du Cerceau. In Breda, about 1535, it was used for the tomb of Engelbert II of Nassau by a sculptor variously identified as Jean Mone, Tommaso Vincidor of Bologna (who was working in Breda at the time), and Cornelis Floris of Antwerp. A woodcut illustration of such supporters appeared in an edition of Vitruvius published in Como in 1521; because this edition was the first printed one to be translated into Italian from Latin, and because it had a good commentary and more illustrations of better quality (Leonardo has been linked with these unsigned illustrations) than any Vitruvius then printed, its woodcuts were well known and often copied. In Nürnberg Peter Flötner adapted the supporter motif for an illustration in Walter Ryff's 1548 German translation of Vitruvius. Du Cerceau may have seen the Como or the Nürnberg Vitruvius, the Breda tomb, or the ultimate source of the kneeling warrior motif—he knew the ideas of his competitors and predecessors and used them in his large print-making business.

164. Almost one hundred years after this monument was installed in the Sacristy of San Lorenzo in Florence, Cornelis Cort, a Netherlander, engraved it with great technical ability. He was by no means the first artist to record the design, although even today one is apt to hurry past this unusual monument on the way to look at Michelangelo's Medici tombs. Unlike the latter, this design includes no human figures. Instead, Andrea del Verrocchio made for Lorenzo and Giuliano de' Medici, in honor of their father, a monumental garland stemming from vases, and a bronze ropework grille to set off the porphyry sarcophagus. A central wreath of laurel leaves bound by a ribbon, and lion's-paw feet turning into acanthus-leaf corners, are elements derived from classical antiquity and are found on many later Renaissance tombs, small bronze caskets, and wooden chests.

164

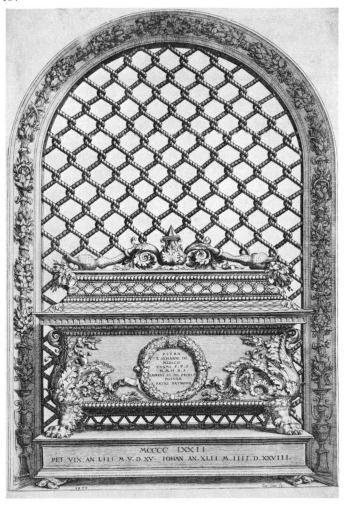

165. Italian Renaissance funerary sculpture, especially wall tombs, often used antique triumphal arches as a basic motif. Visiting northerners found this especially suitable for royal tombs—Roman triumphal arches, for example, shelter the sarcophagi of Francis I and of Henry II in Saint-Denis. On a slightly less imposing scale than tombs for royalty were tombs for nobility, whose armor-clad figures not only lay in state like their medie-val predecessors, but occasionally reclined, leaning on an elbow and gazing into eternity. Portraits of the deceased kneeling in prayer were popular choices for tombs, which were sometimes ordered years before the client's death, but the grisly naked corpses and skeletal portraits of the 1540s were no longer fashionable at the end of the century.

Our highly finished French drawing of a double tomb shows portraits of the deceased

165

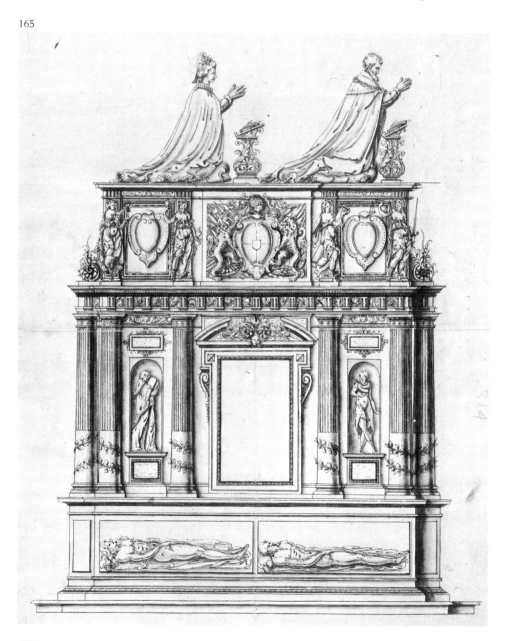

in both life and death. Unidentified allegorical figures in niches, four of the seven virtues, and a blank coat of arms (indicating only that the lady was an heiress and that she was illegitimate) decorate this monument.

Arfe y Villafañe, included it in his book, *De varia commensvracion para la escvltvra y architectura* (Seville, 1585). Neither a sculptor nor an architect, Arfe was a goldsmith who created custodias for the cathedrals of Seville and Valladolid. Sometimes seven feet high, gold or silver-gilt towers like this one contained the consecrated wafer and were carried or wheeled through the streets in procession on the feast of Corpus Christi.

166, 167. A truly architectural structure is this portable custodia. Its designer, Juan de

166

167

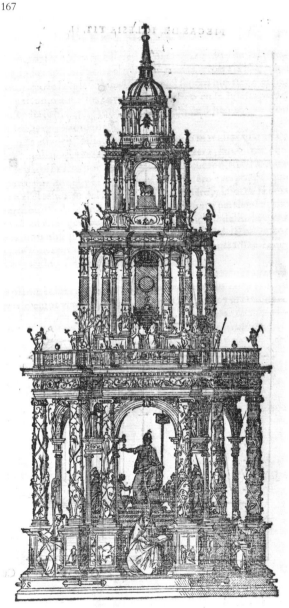

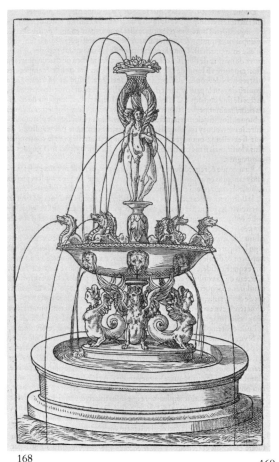

168

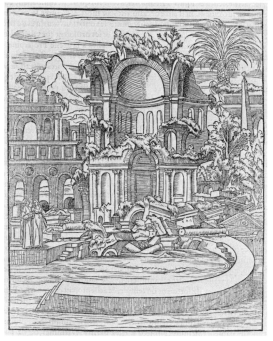

169

168, 169. Francesco Colonna's *The Dream of Poliphilo* includes so much information about buildings and gardens that one architectural historian, William B. Dinsmoor, described it as a commentary (in the form of a novel) on Vitruvius's *Ten Books of Architecture* and the earliest printed architectural book with illustrations. It first appeared in Venice in 1499. The French translation, printed in Paris in 1546, used recut versions of the original woodcuts and a changed layout; it is one of the most beautiful of all Renaissance books. The often-copied images inspired illustrations by Peter Flötner and Virgil Solis for Walter Ryff's German translation of Vitruvius (1548).

The dreaming hero, Poliphilo, wanders in a garden past a fountain made of amethyst, chalcedony, jasper, and porphyry (168). Three golden harpies rest on the fountain's ophite plinth, and three life-size Graces of gold eject crystal-clear water from their breasts, a favorite motif for fountain design throughout the sixteenth century.

In his wanderings with the lady Polia, Poliphilo arrives at a ruined temple, and together they enter in order to read the epitaphs on the antique tombs. Polia and Poliphilo walk behind the temple (169), where the first thing they see is an obelisk of red stone, supported by four balls and with a ball on top. In effect emblems of Rome, obelisks were used on monuments and in otherwise unidentifiable landscapes to set a scene as antique.

170, 171. Ensuring an adequate supply of water for any city, house, or palace is a perennial concern. The sixteenth century was no exception, and wellhouses and fountains were designed by many important sculptors and architects. In 1568 Jan Vredeman de Vries made a set of prints he called "perspective views for nobility." The views included public fountains, watering troughs, and wells for

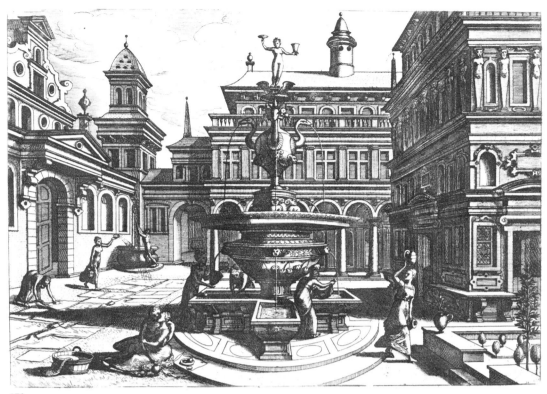

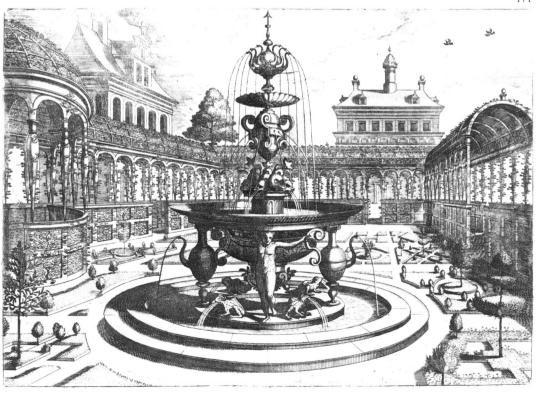

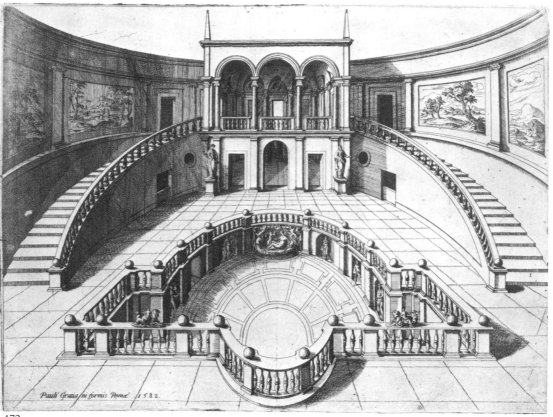

Pauli Gratia/ni formis Rome 1582.

172

cities, along with elaborate fountains for palace courtyards and gardens. One courtyard or plaza has a fountain with two levels of catch basins, the lower of which could be used by laundresses as a washtub. Drying linen is spread out on the grass for bleaching, and a servant sprinkles it with water to hasten the process. An ordinary well in the corner of the courtyard has an overhead wheel for a chain or rope hoist.

A large trellis encloses a knot garden containing a fountain with spouting frogs, dolphins, and vases to cool the air on a summer's day. Vredeman was totally unconcerned with the mechanics of hydraulics.

172, 173. An enclosed garden courtyard, begun in 1551, was built for Pope Julius II behind his villa outside the walls of Rome. Filled with the sound of dripping water, it had an elevated loggia to catch breezes and

a hidden stairway leading down to cool and shady seclusion where water nymphs dwelt.

174. Antique Roman triumphal arches inspired a variety of ornament designs. They were used in intarsia panels for furniture and walls, on the title pages of books, as facades for palaces, as garden gates, court cupboards, and tombs, and for temporary arches of triumph erected for royal entries imitating Roman processions. Rudolf Wyssenbach, the same *Formschneider* who published the woodblocks after Peter Flötner's moresque designs (16, 18, 19), copied in reverse a set of etchings by Du Cerceau and signed the copies with his monogram, RW, his woodcutter's tools, and his address. Not content to copy the restrained classical structures as rendered by Du Cerceau, Wyssenbach added figures that he considered classical, along with out-of-scale monsters and winged children.

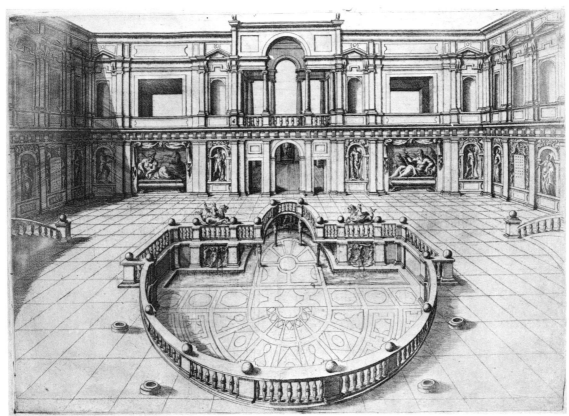

173

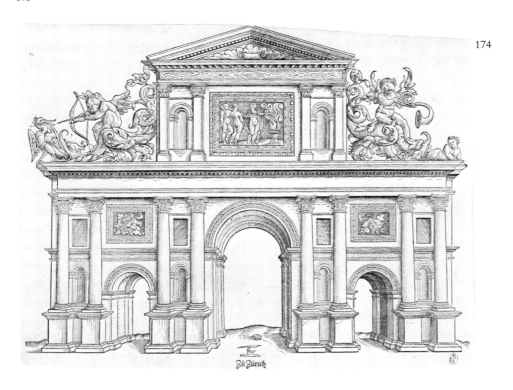

174

Zů Zürich

131

175. In 1549 Philip II of Spain, then a young prince, made a triumphal entry into Antwerp. The whole city was decorated at great expense, and festivities lasted for five days. In imitation of Roman antiquity, many of the decorations were triumphal arches, including five elaborate ones created by Germany, Spain, Florence, and Geneva, according to Cornelius Grapheus, author of a book describing the occasion. Of the 1,716 artists and construction workers required, the city of Antwerp paid 641 "carpenters, painters, designers, personages, and common workers" to erect (under the direction of Pieter Coecke van Aelst, who illustrated Grapheus's book) a series of smaller arches or scaffolds for tableaux in various parts of the city. Every arch had an iconographical program, and the scaffold illustrated on leaf K shows Prince Philip between two other young princes with

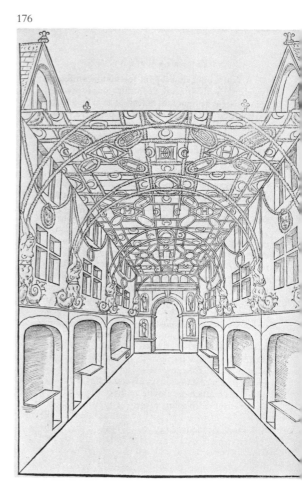

176

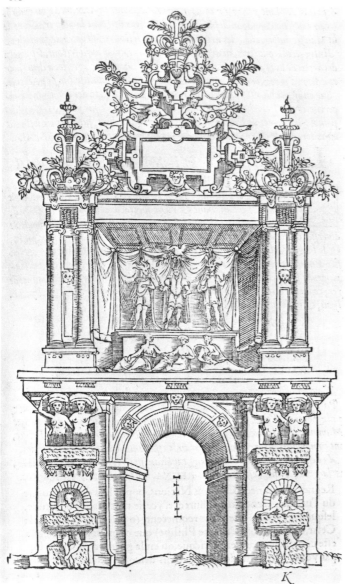

175

burning flames on their heads, signifying that in the future each would be a king. Philip, however, was destined to be an emperor; therefore an eagle with a laurel branch descends over his head. At his feet recline in all due humility three ladies representing the

"three principal parts of the world," Asia, Africa, and Europe.

Although the idea of a triumphal arch is a classical concept, the execution here is anti-classical. Antwerp mannerist ornament—imprisoned men, half-length caryatids, five sets of nonfunctional dentils, a crested top with a half-person whose head is in the lower loop of the empty cartouche—was accumulated for a seventy-foot structure.

176. In 1549 the Pont Notre-Dame in Paris was decorated for King Henry II to ride across as he made his triumphal entry into Paris. Houses and shops on the bridge were decorated with an arcade of ivy garlands supported by double-tailed mermaids. The interlacings of the ivy garlands contained the king's initial H in gold on a blue ground. The silver crescents on a black ground and the double D's alluded to the king's mistress, Diane de Poitiers. At either end of the bridge was a triumphal arch.

177. Assembled for an intarsia pattern, almost recognizable Roman ruins dwarf the figure of an artist sketching. On a tablet, over a statue of Hercules in a niche at the right, is Jacques Androuet Du Cerceau's name in Latin. It is much more elegantly and clearly displayed than the names of the fifteenth- and sixteenth-century artists who wrote on the ceilings of the then unexcavated vaults (grottoes) of the Golden House of Nero. Du Cerceau published this set of architectural fragments *(Fragmenta structurae veteris)* in Orléans in 1550, using the drawings of the Netherlander Léonard Thiry. On his title plate Du Cerceau says the designs are not his own invention but are by Thiry, "who recently died in Antwerp." This appears to be the only occasion on which Du Cerceau mentioned another ornament designer whose work he copied; Thiry may have been Du Cerceau's friend.

177

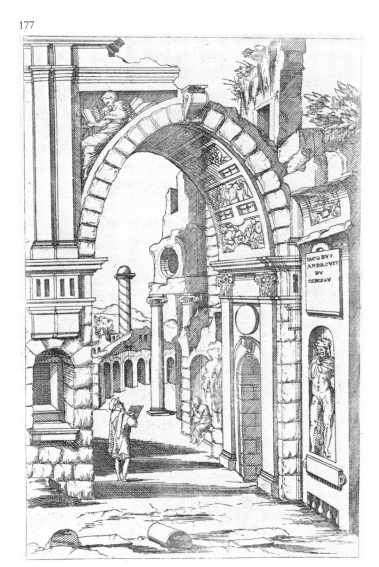

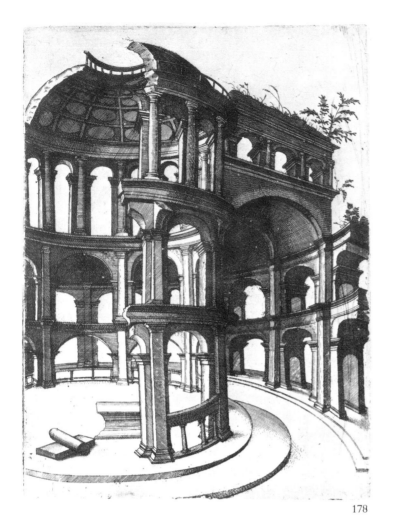

178

178. Part of the sixteenth-century taste for ruins resulted from their evocative quality. To northerners who had never been to Italy, who knew it only from innumerable engraved views, a ruin represented antiquity. The addition of the letters S.P.Q.R. could make any crumbling colonnade, obelisk, or monumental column stand for the rise and fall of Roman civilization. "Roman" ruins were especially popular intarsia patterns.

An engraving of a circular colonnaded building in ruins is a direct copy by an unknown Netherlander of a plate by an Italian, Master G.A. Working in Rome and Naples (1535–50?), Master G.A. engraved a set of eighteen views of ancient Roman monuments (for example, the Colosseum, several triumphal arches, the Baths of Diocletian, and Hadrian's Tomb), identifying each building with an inscription on the metal plate. Of antiquarian and topographical interest, Master G.A.'s plates were purchased by tourists and scholars. However, when the unknown Netherlander copied Master G.A., he made no attempt to identify the subjects; he was producing a set of intarsia designs, not topographical views for tourists.

179

179. A solitary figure in a nightmarish setting of ruined buildings measures a diagram with an architect's divider. Usually called *The Architect,* she might more properly be called *Geometry* or *Perspective.* No doubt emblematic, with its tortuous stairway leading nowhere and a shining sun-face in the upper right, this little print (by a Frenchman from Lyons who worked between 1531 and 1554) may have been an invention for an intarsia panel.

180

180. Often considered a stage set, this peculiar mélange of Roman and Florentine buildings is more probably a design for a horizontal panel of intarsia. An unknown engraver whose understanding of perspective was incomplete (see the pavement to the left of the hexagonal building) composed a city street according to a formula in which sidescreens with porticoes and arcades lead into the distance with the help of patterned pavements.

135

182

183

181. Another architectural perspective for intarsia is composed of an arcaded building with a vista to a series of freestanding columns serving no purpose except to fill a compositional hole. Not a view of an existing place, the pattern looks enough like Rome so that a well-meaning collector in the nineteenth century had it bound with Antonio Lafreri's views of Rome. Surely it is part of an Italian set of intarsia patterns so far unidentified.

182, 183. Du Cerceau called his set of circular architectural designs *Vues d'optique*. For one of the plates (182) he copied (in reverse) an engraving (183) by Jean de Gourmont, who worked from 1506 until his death in 1551, the same year in which Du Cerceau published his *Vues d'optique*. Gourmont was a goldsmith, which explains his repeated use of a circular shape. Since he did not date his prints, there is no way to tell when he engraved his *Child Near a Portico*. It is very probable that he too copied an earlier design, perhaps by the Italian Nicoletto da Modena.

184

184. After 1551, when Du Cerceau's *Vues d'optique* was published, some of the plates were copied in reverse by Michele Greco, called Lucchese. Adding a few recognizable views of Rome—the Castel Sant'Angelo, for example—Lucchese issued a rectangular set called *Prospettive diverse*. Plate 1, illustrated here, is a perspective study for the use of inlayers, not a view of Rome.

185. Jan Vredeman de Vries called his city streets and architectural views "perspectives," even entitling one publication *Scenographia*. Imaginary views, the plates are not merely studies in perspective, nor are they actual stage sets. A horizontal panel with an oval frame comes from an untitled set of plates designed by Vredeman about 1560. An excellent exercise in perspective, it contains an adaptation of the Column of Trajan and Italian colonnades ending in Flemish towers and public buildings. With the stage above eye level and no room for actors center stage, this design can have nothing to do with the theater. Instead, it is an intarsia design, probably intended for bone or ivory inlaid in an ebony court cupboard of a kind especially popular in the north of Europe well into the seventeenth century.

186. Intarsia became increasingly popular in northern Europe in the sixteenth century. Floors, walls, tabletops, court cupboards, game boards, chests, gunstocks, and all manner of precious wooden objects were inlaid with colored materials. A set of twenty-six plates with geometric patterns was etched by Du Cerceau, and although the designs are for marquetry, they could also be used for embroidery, knot gardens, or bookbinding.

185

186

Credits

1. Rogers Fund, 1922 (22.67.4)
2. Rogers Fund, 1922 (22.67.5)
3. Harris Brisbane Dick Fund, 1930 (30.54.40)
4. Rogers Fund, 1922 (22.67.54)
5. Harris Brisbane Dick Fund, 1929 (29.16.3)
6–8. Gift of J. Pierpont Morgan, 1927 (27.114)
9. Rogers Fund, 1922 (22.73.2)
10. Harris Brisbane Dick Fund, 1924 (24.68.2)
11. Fletcher Fund, 1919 (12.73.147)
12. Harris Brisbane Dick Fund, 1935 (35.75.3)
13. The Elisha Whittelsey Collection, The Elisha Whittelsey Fund, 1952 (52.570.212)
14. The Elisha Whittelsey Collection, The Elisha Whittelsey Fund, 1961 (61.581.8)
15. Harris Brisbane Dick Fund, 1947 (47.79.1)
16–19. Harris Brisbane Dick Fund, 1925 (25.49)
20. Harris Brisbane Dick Fund, 1937 (37.13.6)
21, 22. Rogers Fund, 1921 (21.15.3)
23. Rogers Fund, 1922 (22.105.9)
24. Rogers Fund, 1921 (21.11.4)
25. The Elisha Whittelsey Collection, The Elisha Whittelsey Fund, 1948 (48.13.12)
26. Harris Brisbane Dick Fund, 1928 (28.22.15)
27. Harris Brisbane Dick Fund, 1928 (28.22.18)
28. Harris Brisbane Dick Fund, 1928 (28.22.24)
29. Harris Brisbane Dick Fund, 1928 (28.22.19)
30, 31. Harris Brisbane Dick Fund, 1933 (33.103)
32, 33. Rogers Fund, 1921 (21.36.140)
34. Harris Brisbane Dick Fund, 1926 (26.57.5)
35. The Elisha Whittelsey Collection, The Elisha Whittelsey Fund, 1949 (49.97.526)
36. The Elisha Whittelsey Collection, The Elisha Whittelsey Fund, 1949 (49.95.391)
37. Harris Brisbane Dick Fund, 1947 (47.8.3(23))
38. The Elisha Whittelsey Collection, The Elisha Whittelsey Fund, 1955 (55.594.4, 8)
39. Harris Brisbane Dick Fund, 1927 (27.74.2)
40. Harris Brisbane Dick Fund, 1926 (26.64.6)
41. Anonymous Gift, 1929 (29.44.26)
42. Harris Brisbane Dick Fund, 1926 (26.105.12)
43. Rogers Fund, 1931 (31.31.34–41)
44. The Elisha Whittelsey Collection, The Elisha Whittelsey Fund, 1949 (49.97.331)
45. Harris Brisbane Dick Fund, 1953 (53.600.62)
46. Rogers Fund, 1966 (66.618.1)
47. The Elisha Whittelsey Collection, The Elisha Whittelsey Fund, 1959 (59.508.98(3))
48. Rogers Fund, 1920 (20.8.1)
49. Harris Brisbane Dick Fund, 1924 (24.68.2)
50. Harris Brisbane Dick Fund, 1930 (30.55.7)
51. Harris Brisbane Dick Fund, 1932 (32.65.3)
52. Harris Brisbane Dick Fund, 1924 (24.10.14(5))
53. Harris Brisbane Dick Fund, 1953 (53.600.58)
54a. Rogers Fund, 1918 (18.12)
54b. Rogers Fund, 1920 (20.88.1)
55. The Elisha Whittelsey Collection, The Elisha Whittelsey Fund, 1950 (50.561.1)
56. The Elisha Whittelsey Collection, The Elisha Whittelsey Fund, 1949 (49.97.308)
57. Harris Brisbane Dick Fund, 1953 (53.600.44)
58. The Elisha Whittelsey Collection, The Elisha Whittelsey Fund, 1951 (51.501.7110(18))
59. Harris Brisbane Dick Fund, 1928 (28.98.4)
60. The Elisha Whittelsey Collection, The Elisha Whittelsey Fund, 1959 (59.508.98(1))
61. The Elisha Whittelsey Collection, The Elisha Whittelsey Fund, 1949 (49.97.180)
62. Harris Brisbane Dick Fund, 1924 (24.10.15)
63. Harris Brisbane Dick Fund, 1953 (53.600.6)
64. The Elisha Whittelsey Collection, The Elisha Whittelsey Fund, 1955 (55.590.24)
65. The Elisha Whittelsey Collection, The Elisha Whittelsey Fund, 1952 (52.570.331)
66. The Elisha Whittelsey Collection, The Elisha Whittelsey Fund, 1952 (52.570.319)
67. The Elisha Whittelsey Collection, The Elisha Whittelsey Fund, 1952 (52.570.322)
68. Gift of Janet S. Byrne, 1981 (1981.1000.1(1))
69. The Elisha Whittelsey Collection, The Elisha Whittelsey Fund, 1949 (49.19.61)
70. Purchase, Gifts in memory of Olivia H. Paine, 1977 (1977.566.1)
71. The Elisha Whittelsey Collection, The Elisha Whittelsey Fund, 1966 (66.545.4(7))
72–74. Harris Brisbane Dick Fund, 1927 (27.74.2)
75. Gift of Janos Scholz, 1943 (43.66.6)
76–87. Harris Brisbane Dick Fund, 1923 (23.39.1–12)
88. Rogers Fund, 1921 (21.30.4)
89. The Elisha Whittelsey Collection, The Elisha Whittelsey Fund, 1951 (51.504.434)
90. The Elisha Whittelsey Collection, The Elisha Whittelsey Fund, 1950 (50.562.90)
91. Harris Brisbane Dick Fund, 1924 (24.49.7)
92. Gift of Felix M. Warburg and his family, 1941 (41.1.168)
93. Purchase, The Sylmaris Collection, Gift of

George Coe Graves, by exchange, 1966 (66.658.6)

94. Bequest of W. Gedney Beatty, 1941 (41.100.138)

95. Purchase, Harris Brisbane Dick Fund and Joseph Pulitzer Bequest, 1971 (1971.513.29)

96. The Elisha Whittelsey Collection, The Elisha Whittelsey Fund, 1949 (49.95.363)

97, 98. Purchase, Anne and Carl Stern Gift, 1958 (58.627.4(1–6))

99, 100. Harris Brisbane Dick Fund, 1953 (53.600.1903(2, 3))

101. Harris Brisbane Dick Fund, 1953 (53.600.51(5))

102. Harris Brisbane Dick Fund, 1941 (41.67)

103. Purchase, Joseph Pulitzer Bequest, 1917 (17.50.16(35, 63, 58, 37, 55, 50))

104. Gift of Junius S. Morgan, 1919 (19.52.19)

105. The Elisha Whittelsey Collection, The Elisha Whittelsey Fund, 1949 (49.20.11)

106. Rogers Fund, 1954 (54.173)

107. Rogers Fund, 1921 (21.11.6)

108, 109. The Elisha Whittelsey Collection, The Elisha Whittelsey Fund, 1952 (52.570.190, 191)

110. Harris Brisbane Dick Fund, 1926 (26.57.48, 49)

111. Harris Brisbane Dick Fund, 1930 (30.67.4(18))

112. Harris Brisbane Dick Fund, 1942 (42.14.5)

113, 114. The Elisha Whittelsey Collection, The Elisha Whittelsey Fund, 1950 (50.562.38, 42)

115. The Elisha Whittelsey Collection, The Elisha Whittelsey Fund, 1968 (68.529.5)

116. The Elisha Whittelsey Collection, The Elisha Whittelsey Fund, 1951 (51.501.5785(1–4))

117. Rogers Fund, 1920 (20.10.1)

118. Bequest of Harry G. Sperling, 1971 (1975.131.73)

119. Harris Brisbane Dick Fund, 1947 (47.139.93)

120. Rogers Fund, 1966 (66.618.8)

121. Harris Brisbane Dick Fund, 1937 (37.86.8)

122. The Elisha Whittelsey Collection, The Elisha Whittelsey Fund, 1949 (49.95.162)

123. Harris Brisbane Dick Fund, 1926 (26.50.1(34))

124. The Elisha Whittelsey Collection, The Elisha Whittelsey Fund, 1951 (51.507.1)

125. Rogers Fund, 1922 (22.41.50)

126. Harris Brisbane Dick Fund, 1928 (28.85.57)

127. The Elisha Whittelsey Collection, The Elisha Whittelsey Fund, 1949 (49.19.66)

128. Harris Brisbane Dick Fund, 1937 (37.40.5(32))

129. Rogers Fund, 1922 (22.113.7)

130. Harris Brisbane Dick Fund, 1936 (36.50.2)

131. Harris Brisbane Dick Fund, 1938 (38.62.10)

132. Harris Brisbane Dick Fund, 1934 (34.61.5)

133. The Elisha Whittelsey Collection, The Elisha Whittelsey Fund, 1950 (50.562.61)

134. Harris Brisbane Dick Fund, 1937 (37.40.5(26))

135. Harris Brisbane Dick Fund, 1937 (37.40.5(27))

136. Rogers Fund, 1922 (22.105.1)

137. Harris Brisbane Dick Fund, 1925 (25.25.15)

138. The Elisha Whittelsey Collection, The Elisha Whittelsey Fund, 1951 (51.501.430)

139. The Elisha Whittelsey Collection, The Elisha Whittelsey Fund, 1951 (51.501.431)

140. Rogers Fund, 1966 (66.621.3)

141. Rogers Fund, 1966 (66.621.2)

142–144. Harris Brisbane Dick Fund, 1926 (26.50.6)

145. Harris Brisbane Dick Fund, 1932 (32.55.1(7))

146. Rogers Fund, 1917 (17.72.43)

147. The Elisha Whittelsey Collection, The Elisha Whittelsey Fund, 1949 (49.95.71)

148. Harris Brisbane Dick Fund, 1928 (28.98.48)

149. The Elisha Whittelsey Collection, The Elisha Whittelsey Fund, 1949 (49.19.39)

150. The Elisha Whittelsey Collection, The Elisha Whittelsey Fund, 1949 (49.19.40)

151. Purchase, Anne and Carl Stern Gift, 1967 (67.651)

152. The Elisha Whittelsey Collection, The Elisha Whittelsey Fund, 1959 (59.605.2)

153. The Elisha Whittelsey Collection, The Elisha Whittelsey Fund, 1968 (68.529.8)

154. Harris Brisbane Dick Fund, 1926 (26.50.1(104))

155. Harris Brisbane Dick Fund, 1941 (41.72(2.11))

156. The Elisha Whittelsey Collection, The Elisha Whittelsey Fund, 1952 (52.570.39–41)

157. Harris Brisbane Dick Fund, 1943 (43.65.12)

158. The Elisha Whittelsey Collection, The Elisha Whittelsey Fund, 1951 (51.501.411)

159. The Elisha Whittelsey Collection, The Elisha Whittelsey Fund, 1949 (49.95.183)

160. The Elisha Whittelsey Collection, The Elisha Whittelsey Fund, 1949 (49.20.8(6))

161. The Elisha Whittelsey Collection, The Elisha Whittelsey Fund, 1967 (67.812.1)

162. The Elisha Whittelsey Collection, The Elisha Whittelsey Fund, 1963 (63.562.2(4))

163. The Elisha Whittelsey Collection, The Elisha Whittelsey Fund, 1963 (63.562.2(69))

164. The Elisha Whittelsey Collection, The Elisha Whittelsey Fund, 1957 (57.572.30)

165. The Elisha Whittelsey Collection, The Elisha Whittelsey Fund, 1949 (49.19.34)

166, 167. Harris Brisbane Dick Fund, 1952 (52.568)

168, 169. Harris Brisbane Dick Fund, 1926 (26.77)

170. The Elisha Whittelsey Collection, The Elisha Whittelsey Fund, 1949 (49.95.2630(3))

171. Harris Brisbane Dick Fund, 1943 (43.44.1(5))

172. Harris Brisbane Dick Fund, 1941 (41.72(3.51))

173. Harris Brisbane Dick Fund, 1941 (41.72(3.52))

174. Harris Brisbane Dick Fund, 1927 (27.84.3)

175. Rogers Fund, 1920 (20.43)

176. Harris Brisbane Dick Fund, 1928 (28.95)

177. Rogers Fund, 1920 (20.82(7))

178. The Elisha Whittelsey Collection, The Elisha Whittelsey Fund, 1948 (48.13.4(65))

179. The Elisha Whittelsey Collection, The Elisha Whittelsey Fund, 1964 (64.568.10)

180. Harris Brisbane Dick Fund, 1941 (41.72(1.16))

181. Harris Brisbane Dick Fund, 1941 (41.72(3.57))

182. The Elisha Whittelsey Collection, The Elisha Whittelsey Fund, 1949 (49.46.57)

183. Harris Brisbane Dick Fund, 1945 (45.5.3)

184. Harris Brisbane Dick Fund, 1927 (27.84.19)

185. Harris Brisbane Dick Fund, 1953 (53.601.20(84))

186. Harris Brisbane Dick Fund, 1931 (31.74.1)

Index of Artists Illustrated

Aldegrever, Heinrich, 39, 54, 92–93, 96–97
Altdorfer, Albrecht, 101, 112–113
Arfe y Villafañe, Juan de, 127

Beham, Barthel, 48
Beham, Hans Sebald, 22, 26–27, 56
Birago, Giovanni Pietro da, 39, 72–75
Boillot, Joseph, 46, 70–71
Bos, Balthazar van den, 36
Bos, Cornelis, 83
Boyvin, René, 43, 45, 46, 84, 94
Bry, Jan Theodor de, 59, 96
Bry, Theodor de, 59, 95

Cellini, Benvenuto, 51, 54, 55
Cock, Hieronymus, 32, 36, 64
Coecke van Aelst, Pieter, 81, 132
Collaert, Hans, 94
Colonna, Francesco, 128
Cort, Cornelis, 125

Decio, Giovanni Antonio da, 61
Delaune, Etienne, 92, 96–97
Domenico del Barbiere, 66–67
Du Cerceau, Jacques Androuet, 13, 16, 19, 35,
 42–43, 61, 66–67, 100–101, 102, 110–111,
 122–125, 130, 133, 137, 138–139
Dürer, Albrecht, 21, 24–26, 30–31, 39–41, 56

Fantuzzi, Antonio, 80–81, 98–99, 122–123
Flindt, Paul, 19, 102–103, 106
Floris, Cornelis, 13, 45, 64, 66, 69
Flötner, Peter, 12, 34–35, 130

Genga, Girolamo, 102
Gourmont, Jean de, 137
Gourmont, Jean de, the Second, 43
Greco, Michele, 138

Holbein, Hans, the Younger, 78–79
Hopfer, Daniel, 30, 44, 52–53, 76–77, 90–91,
 108–109, 114–115, 121
Hopfer, Jerome, 101
Hornick, Erasmus, 96–97
Huys, Frans, 45

Jamnitzer, Wenzel, 107

Leinberger, Hans, 47
Leonardo da Vinci, 30, 59, 125
Ligorio, Pirro, 68–69, 116–117
Lucchese, 138

Mantegna, Andrea, 51, 56–57
Master AP, 44–45
Master CG, 56–57

Master f, 30, 32–33, 34, 36
Master G.A., 134
Master GI, 58–59, 77
Master Guido, 96–97
Master HS, 18
Master L.D., 118–119
Master of 1551, 107
Master of 1573, 14
Master of the Craterography, 107
Master of the Die, 49–50
Master of the Sforza Book of Hours, 72
Master with the Name of Jesus, 45
Musi, Agostino, 62

Negker, Jost de, 48

Ostaus, Giovanni, 36–39
Ostendorfer, Michael, 113

Perino del Vaga, 50
Porta, Giuseppi della, 39

Rosselli, Francesco, 26–27, 76–77
Rosso, 46, 85

Salamanca, Antonio, 44–45
Salomon, Bernard, 39
Salviati, 39
Salviati, Francesco, 98
Serlio, Sebastiano, 14, 62, 81, 120–121
Sibmacher, Johann, 104
Silber, Jonas, 19, 104–105
Solis, Virgil, 39, 95, 104–105
Sylvius, Balthazar, 19, 36

Tagliente, Giovanni Antonio, 32
Thiry, Léonard, 85, 133

Udine, Giovanni da, 49, 62

Veneziano, 62–63, 99
Verrocchio, Andrea del, 125
Vico, Enea, 15, 33, 55, 60, 82–83, 88–89, 99
Vogtherr, Heinrich, 20–21
Vredeman de Vries, Jan, 64–65, 70, 72, 86–87,
 128–130, 138–139

Wechter, Georg, 19, 38–39
Weiditz, Hans, 48
Woeriot, Pierre, 91, 94
Wyssenbach, Rudolf, 35, 130–131

Zan, Bernhard, 52, 103
Zoan Andrea, 54, 72–75
Zoppino, Nicolo, 52, 121
Zündt, Mathias, 19, 98, 107

Photographs by Gene C. Herbert, Alexander Mikhailovich, and Laurie Heller, Photograph Studio, The Metropolitan Museum of Art

Composition by LCR Graphics, Inc., New York
Printing by Mercantile Printing Co., Inc., Worcester, Massachusetts
Binding by New Hampshire Bindery, Inc., Concord, New Hampshire